The Prairie Dog

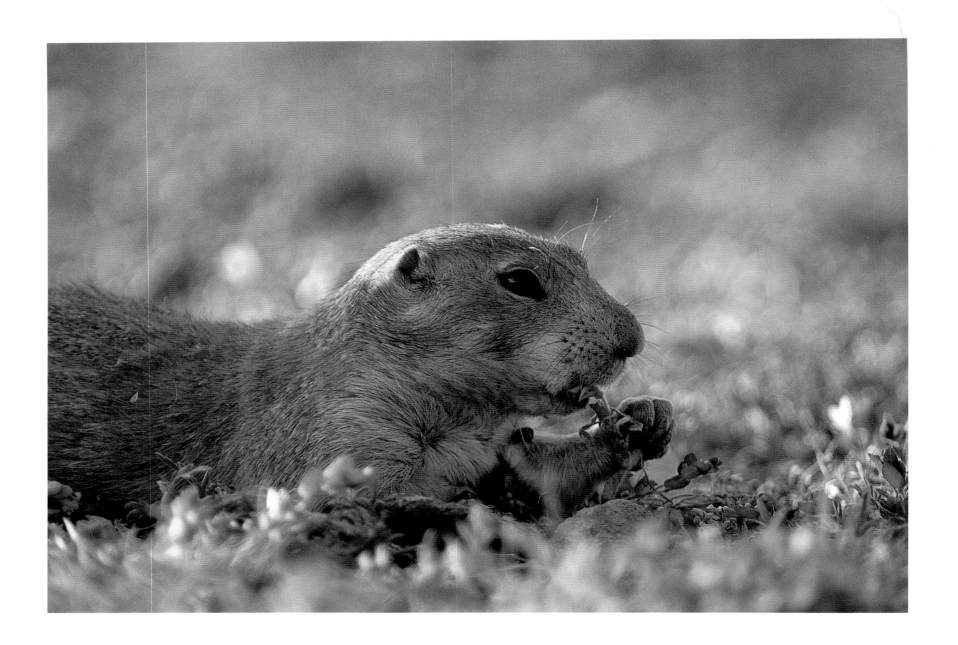

The Prairie Dog
Sentinel of the Plains

Text and Photography by Russell A. Graves

Texas Tech University Press

This book was set in Palatino and Calligraph 421 BT. The
paper used in this book meets the minimum requirements of
ANSI/NISO Z39.48-1992 (R1997).∞

Printed in China

Design by Brandi Price

Library of Congress Cataloging-in-Publication Data
Graves, Russell A., 1969–
 The prairie dog : sentinel of the plains / text and
photography by Russell A. Graves.
 p. cm.
 Includes bibliographical references (p.).
 ISBN 0-89672-456-5 (cloth : alk. paper) — ISBN
0-89672-455-7 (pbk. : alk. paper)
 1. Prairie dogs. I. Title.
 QL737.R68 G7 2001
 599.36'7--dc21
 2001001825

01 02 03 04 05 06 07 08 09 / 9 8 7 6 5 4 3 2 1

Texas Tech University Press
Box 41037
Lubbock, Texas 79409-1037 USA

1-800-832-4042
ttup@ttu.edu
www.ttup.ttu.edu

Contents

To Kristy and Bailee—my two favorite girls

Acknowledgments

An undertaking of this magnitude would never have been possible without the help of a number of people who lent me their time, talents, and expertise. Kevin Mote, Dana Wright, and Brad Simpson of the Texas Parks and Wildlife Department were extremely helpful in pointing me toward professional journals and other publications in which I could find information. Dr. John Hoogland of the University of Maryland helped me distinguish fact from fiction when it came to prairie dogs and provided insight into their lives through his many years of research on them.

Richard and Steve Bird and Stephen Elliott provided me with some of the finest prairie dog habitat in which to photograph dogs in the wild. Sue Haile, Childress High School librarian, was especially helpful in locating obscure publications. Debbie Wilson, Childress High School English teacher, and Donna Novak were helpful in finding grammatical mistakes and refining the manuscript. I thank the Childress Lions and Rotary Clubs and my students at Childress High School for providing me with candid responses to my photos and smart questions that challenged me to think on my feet and learn more about the prairie dog and its complex ecosystem.

In addition, thank you, Momma and Daddy, for teaching me to love the outdoors and life.

The Llano Estacado, southern homeland of the black-tailed prairie dog.

Introduction

As I stepped from my Chevy pickup onto the soil of the Pitchfork Ranch, it was like stepping back in time. The only sound was that of a nearby windmill creaking out a steady cadence as a soft predawn breeze assisted the mammoth structure in its only chore: sucking precious water out of the hard West Texas ground. I was visiting the historic ranch, covering one hundred thousand acres in King and Dickens Counties in the big ranch country east of Lubbock, Texas, at the invitation of ranch manager Bob Moorehouse. After a quick breakfast at the cook shack with a few of the cowboys and some early morning conversation and directions, I was off to the pasture.

The tires of my truck kicked up a cloud of dust as I made my way down the winding ranch roads. The windows were open, so every time I slowed, a thick curtain of dust invaded the cab and settled over the seat and dash. Before long I found my destination—a pasture whose name I cannot remember, but I am sure it had a poetic ring to it. Most historic

ranches name their pastures after old line camps, geographic features, or an old cowpuncher. Names like Moon Camp or Mouth of River Pasture always add to the allure of the great beef factories.

As the sun painted the eastern sky an almost surreal shade of pinkish orange, cattle began to stir in the distance, and their bawls came more often. The faint light revealed the scattered mesquite trees and cholla cactus that dot this great prairie. The landscape began to come alive as birds darted here and there. A jackrabbit loped across a field road, and armies of red ants began scurrying about, foraging for the day's sustenance. Startled at my presence, a great blue heron, destined for a small overflow pond near the windmill's tank, squawked and lumbered off into the distance like a great prehistoric pterodactyl.

At last I spotted what I was looking for. Circular mounds of red dirt confirmed their presence despite the lack of other visual proof. Suddenly a shrill "wee-oh!" interrupted the solitude of the moment. I had found a colony of black-tailed prairie dogs.

As sunlight erupted over the horizon, spilling over the landscape, the little sentinels of the prairie began to come awake. Sitting on their rumps to gain a better perspective, their sentries gazed across the terrain, looking for the first sign of danger. They spotted me, as I made no attempt to hide myself except to lie prone on the ground. Alarmed at first, some scurried with surprising speed from one burrow to another,

while others popped their heads up and down from their holes, curiosity obviously getting the better of them. After a few tense minutes and several barks, they began to accept me as a casual observer and not a predator.

Scanning the small town with my binoculars, I found a pair sitting up contently on the rim of their burrow about seventy-five yards away. I inched my way closer, trying not to alarm them. When I finally got into range, I raised my motor-driven camera, equipped with a big 400-mm lens, to my eye and fired off a frame—then another and another and another. A relationship that had started with guarded skepticism on the part of the prairie dogs had turned into one of trust. They let me photograph them for several minutes as the sun climbed higher in the sky, while their companion of the prairie, the burrowing owl, whizzed overhead.

For a moment I might have been the lone human in the world. Looking through the lens of the camera was almost like being in a time machine. In the prairie dog world of the Pitchfork Ranch, for that one moment, all was as it has been for thousands of years. I looked upon the animals with the eyes of a child, or those of a nineteenth-century pioneer sighting the little diggers for the first time.

Once found in vast "towns" throughout the Great Plains, prairie dogs numbered in the millions. Land use and eradication measures have eliminated much of their population, and now they are found only in isolated pockets that dot the

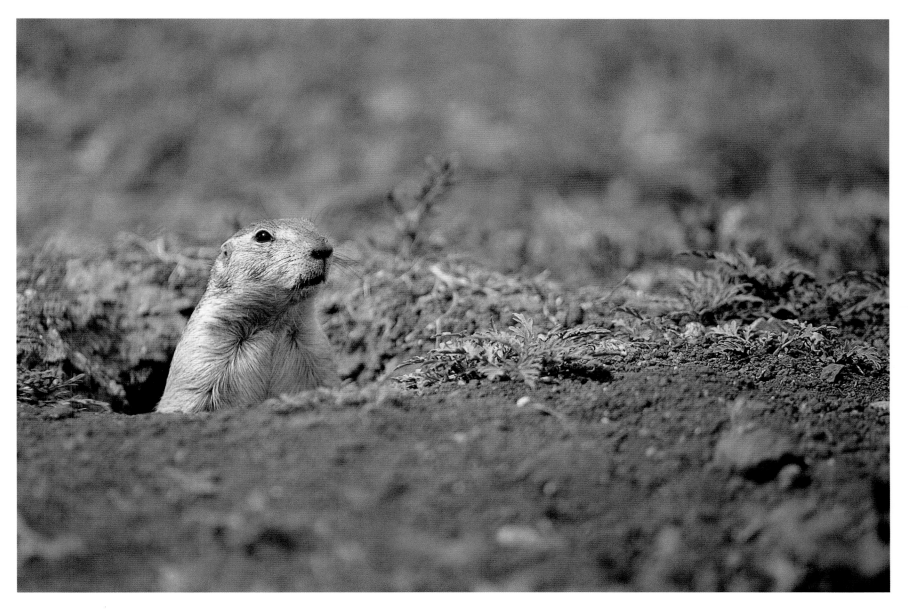

A prairie dog pokes its head from a burrow entrance to scout for possible danger.

landscape here and there over their former range. The black-tailed prairie dog is one of those animals in the precarious position of being either loved unconditionally or hated unmercifully, with hardly any middle ground. Over the years it has been revered by some cultures of the Plains Indians, yet cursed by farmers and ranchers trying to scratch out a living on the barren and hard ground of the plains in competition with the little rodents for grass and space and water.

The black-tailed prairie dog has a long and colorful past, albeit a sometimes unclear future. In the beginning of a new century, it is becoming apparent that in order to manage wildlife resources wisely, we should not focus on a single species in our management programs. Instead, we must take a holistic approach, realizing that the sum of the parts is not greater than the whole. With that approach in mind, some key players in the conservation game are beginning to develop management plans that involve the rotation of prairie dog towns on grass pastures and cultivated lands so that man and the prairie dog can live on the prairie together.

The prairie dog's role in the ecology of the plains is a natural one. Like the grass and the pronghorn antelope, it fits the vastness of the region. This book examines some of the myths, folklore, biology, and habits of the Great Plains digger and tries to shed some light on this shy yet animated creature and its past, present, and future roles as a component of the prairie ecology.

The Red River in the Texas Panhandle cuts through historic prairie dog country of the Southern Plains.

A Brief History of the Prairie Dog

On June 26, 1852, Randolph B. Marcy, captain of the 5th Infantry of the United States Army, was traveling with his band of men along the Red River in the northwest Texas frontier. He was there on a commission from the U.S. government to explore the lands that border the Red River from its headwaters in New Mexico to central Oklahoma. At the time, the land he was exploring was a vast and wild frontier that was still home to black bears, lobo wolves, mountain lions, and plains bison. It was also home to the black-tailed prairie dog (*Cynomys ludovicianus*), a ground-dwelling rodent species that covered the plains from horizon to horizon.

Upon approaching a colony of prairie dogs, Marcy wrote in his journal:

> Our road during the whole day has passed through a continuous dog-town, and we were

often obliged to turn out of our course to avoid the little mounds around their burrows.

In passing along through these villages the little animals are seen in countless numbers sitting upright at the mouths of their domicils [sic], presenting much the appearance of the stumps of small trees; and so incessant is the clatter of their barking, that it requires but little effort of the imagination to fancy oneself surrounded by the busy hum of a city.

The immense number of animals in some of these towns, or warrens, may be conjectured from the large space which they sometimes cover. The one at this place is about twenty-five miles in the direction through which we have passed it. Supposing its dimensions in other directions to be the same, it would embrace an area of six hundred and twenty-five square miles, or eight hundred and ninety-six thousand acres. Estimating the holes to be at the usual distances of about twenty yards apart, and each burrow occupied by a family of four or five dogs, I fancy that the aggregate population would be greater than any other city in the universe.[1]

Marcy was not the first person of European descent to see the prairie dog in its native habitat; in fact, he missed that honor by more than three hundred years. That claim possibly belongs to the Spaniard Cabeza de Vaca, who wandered through Texas about 1532. Without a doubt, though, Cabeza de Vaca's successor, the explorer Coronado, crossed paths with the prairie dog as he and his men traversed the vast expanses of the Llano Estacado, the "Staked Plain," in 1541 in search of fabled cities of gold.[2] The gregarious rodent was not given a name, however, until French explorers Louis and François Verendrye passed through the animals' towns while exploring what is now Montana and the Dakotas in 1742. After seeing the diminutive creature that yipped and barked incessantly, they dubbed it *petit chien*, or "little dog."

It was not until the two-year expedition of Meriwether Lewis and William Clark from the Mississippi to the Pacific Coast in 1804–1806 that the prairie dog's place in history was set. Captain Lewis first dubbed the animal a barking squirrel. Later during the expedition, however, members of the party collected specimens of prairie dogs for scientific study by pouring barrels of water into holes and capturing the inhabitants alive when they ran out. A transcript of the expedition's journal relating to the capture and examination of the animals reads: "The petit chien [little dog] are justly named, as they resemble a small dog in particulars, though they have also some points of similarity to the squirrel. The head resembles the

squirrel in every respect, except that the ear is shorter; the tail is like that of the ground-squirrel; the toe-nails are long, the fur is fine, and the long hair is gray." With that, Lewis gave the furry animal a name that stuck for good—the prairie dog.

Upon the expedition's return to Washington, D.C., in 1806, it brought with it a live black-tailed prairie dog. Scientist George Ord studied the little mammal and in 1815 assigned it the scientific species name *ludovicianus,* the Latin form of the name Ludwig, or Lewis, in honor of Meriwether Lewis.

Throughout the rest of the nineteenth century, as the plains became more heavily populated, prairie dogs became increasingly a feature of everyday life, and in some cases they were hunted for food. While working as a scout for the Texas Rangers in the late 1850s, Charles Goodnight, who would later gain fame as a Texas Panhandle pioneer, cattle rancher, and trailblazer, was with his band of men exploring the land that lies to the west of the Texas cross-timbers—a band of oak forest that runs from central Texas north across the Red River into Oklahoma. Goodnight relates that on one particular foray the going got rough for the Rangers in the rolling plains of northwest Texas. The detachment of men had been on the range for a good while, supplies were becoming scarce, and the prospect of finding any water was also in doubt. The water, with its high gypsum content, was mostly undrinkable because of the inevitable stomach sickness that would result.

Food, however, was another matter. In his book *Charles Goodnight, Cowman and Plainsman,* historian J. Evetts Haley quotes Goodnight as noting that because they were out of the buffalo range, and there were no rabbits to speak of because of predation by coyotes and wolves, the only source of meat protein they could reliably count on was that which the prairie dog could offer. Goodnight says that the prairie dogs were good fare, but they were small and hard to get. He believed that half the prairie dogs he shot would fall back into their burrows and kick themselves past the first bend, where they could not be reached. The prairie dogs that were harvested were usually "fat and made good soup." Men would put flour and prairie dog meat into soup in order to thicken it. Usually, according to Goodnight, prairie dog soup wasn't very filling; after two or three hours one was ready to eat again. He emphasized, however, that prairie dogs beat no meat at all.

As Goodnight immersed himself in the rhythmic beauty of the plains southwest of present-day Amarillo, he went from admiring prairie dogs as a source of food to appreciating their role in the life of the plains. Establishing a camp on his newly formed JA Ranch in the lower reaches of the Palo Duro Canyon, on the Prairie Dog Town Fork of the Red River, Goodnight became perhaps the first conservationist on the Texas Plains. "Except for the buffalo, perhaps no Plains creature interested Goodnight so much as the impertinent little

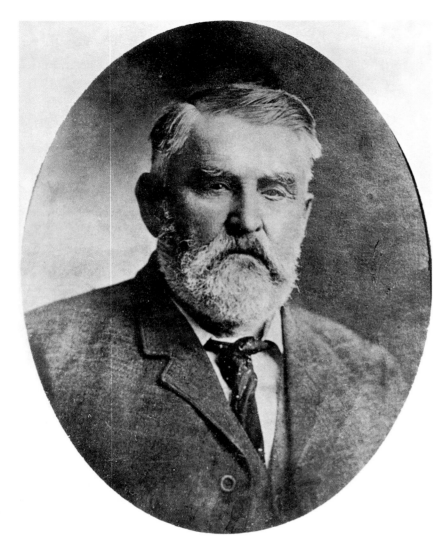

Charles Goodnight, Texas Panhandle explorer and rancher.

prairie dogs," writes Haley in the Goodnight biography. Goodnight was an ardent student of the plains and its inhabitants. He noted that during the Civil War the land around Vernon was eaten clean by hordes of prairie dogs, which then moved on. When the grass came back, however, the region quickly "re-dogged." Goodnight recalled that in his years on the plains he watched entire prairie dog towns in Colorado become abandoned as the dogs migrated, extending their range 150 miles to the southeast.

Once, while on the trail with a herd of cattle in the winter of 1869, Goodnight was swimming the Platte River in Nebraska during an icy flood when he noticed that the stream was full of prairie dogs swimming for its south bank. He swam among them, snatching one from the water and placing it behind the cantle of his saddle. When he reached the shore, he put it in the chuck wagon and kept it until the outfit got back to the Pecos River in Texas. There, when he put the little prairie dog out to graze at their camp, its playful antics made it a favorite of the cowboys. According to Goodnight, "the boys had a hell of a time playing with it."

No doubt such scenes led to the folklore and myths about the prairie dog repeated in many children's books. Even before European cultures immortalized the prairie dog, however, the Plains Indians had already been passing down stories about it for generations. Some cultures of Plains Indians called the little burrower "wishtonwish," a name based on the shrill

call of the dogs. The Native Americans related stories of a famine that once descended upon land that was an abundant forest. All things living were suffering. Therefore, the Great Spirit, realizing the plight of the inhabitants, planned a feast. Many guests at the feast anticipated the meal. As they sat down and took the first bite, the patrons realized that the meal was highly seasoned, and they began to cough uncontrollably. The coughing offended the Great Spirit, and out of anger he turned the guests into prairie dogs and cast them into the desert, where no one could hear their coughing.

Perhaps one of the most raucous stories about the prairie dog has risen from the tales of Pecos Bill, a wild fictitious character of western American folklore who is famous for being raised from a baby by coyotes, using a rattlesnake as a lariat, and roping a tornado. While building a ranch in Texas, Bill needed a way to dig postholes quickly and effectively. He first tried badgers, but he found that they dug crooked holes. Because of his dire situation, Bill used prairie dogs to keep his fence in line. He gathered up several of the rodents and put them to work. When a prairie dog would get two feet deep, Pecos Bill would yank it up and put a post in the hole.

Still another tall tale originated on the plains of Nebraska during the time of a great heat wave and a plague of grasshoppers. Natural scientist Febold Feboldson, another fictional character, was considered a genius among his peers during the 1800s. Febold's most famous contribution to Nebraska's culture was the prairie dog. In what became known as the Year of the Grasshopper, a giant plague of the insects descended upon the land and clouded the sky "like the Milky Way." One evening, the story goes, while staring out the window at the swarm, Febold conjured up the notion of bringing prairie dogs to the plains to eat the grasshoppers. He concluded his cognition with the simple question to his wife, "I don't think anybody will mind them, do you?"

The fascinating history of the prairie dog, both real and spun, is steeped in images of the wild and untamed frontier of the American West. Prairie dogs play a part in the identity of the plains and its cultures, both past and present.

The Black-Tailed Prairie Dog and Its Kin

The canine inference of Meriwether Lewis's name "prairie dog" is somewhat misleading. The black-tailed prairie dog is actually a member of the squirrel family and is in no way related to canines. From a taxonomic standpoint, this burrowing rodent belongs to the family Sciuridae, the family of ground squirrels, tree squirrels, marmots, flying squirrels, and chipmunks.

Five species of prairie dogs are at home on the North American plains. The five are the Mexican (*Cynomys mexicanus*), the white-tailed (*Cynomys leucurus*), the Utah (*Cynomys parvidens*), the Gunnison's (*Cynomys gunnisoni*), and, of course, the black-tailed (*Cynomys ludovicianus*). The five species are similar, but each has distinctive features. From a genetic standpoint, the species of prairie dogs differ only slightly from each

other; all except the Gunnison's have fifty diploid chromosomes in each cell.

Aside from the black-tailed prairie dog, four other species are indigenous to the North American continent. Three of those species live in the western part of the United States, and one, the Mexican prairie dog, lives only in the interior part of Mexico. Although all prairie dogs are similar by their taxonomy, each species differs somewhat in size, range, and population. The black-tailed is the most abundant and the most colonial and occupies the largest range of all the species of prairie dogs in North America.

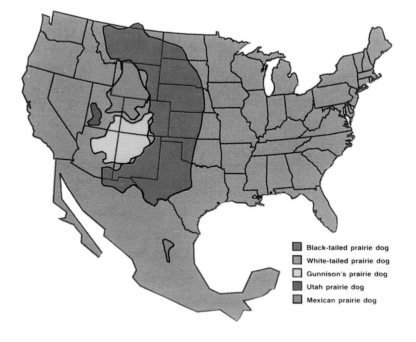

Prairie dog range. (Map by Paul Rand; courtesy University of Nebraska–Lincoln, Department of Forestry, Fisheries, and Wildlife)

The Black-Tailed Prairie Dog

The black-tailed prairie dog is the most common of the five species. It is a diurnal animal, which means that it primarily carries on its activities of feeding and socializing throughout the daylight hours. It is active year-round throughout its range and does not hibernate, as do some members of its family. In fact, in good weather black-tails spend as much as 95 percent of their time above ground during the daylight hours. Studies have shown that when the temperature rises above 81 degrees Fahrenheit, prairie dogs often adjourn below ground for several fifteen- to twenty-minute "cooling off" periods.

The typical black-tailed prairie dog grows to be from fourteen to seventeen inches in length, with approximately one-fifth of that span being tail. The black-tail weighs, on average, one to three pounds when fully grown. It ranges from a yellowish to a buff color, with a whitish belly. Its tail, tipped in black, giving rise to its name, grows to be two to three inches long.

All prairie dogs differ anatomically from their close relatives, the squirrels, in that they have a larger body, larger teeth, and broader skull. Black-tailed prairie dogs are equipped with small ear openings surrounded by small folds of skin and placed well toward the back of the head. Prairie dogs' eyes are placed, like those of most prey species, on the sides of the head so that they provide a broader angle of peripheral vision. Although they may appear to be black, the eyes are yellow-orange. The muzzle of the prairie dog is equipped with a small button nose bordered on each side by long, black whiskers.

From top to bottom, the prairie dog is an animal with a distinct taper. Its head, sleek and streamlined, blends well into its shoulders and forelegs, but as the body extends toward the posterior, it becomes wider. This tapered shape allows the prairie dog to dig and burrow into holes with ease. It also provides an adequate support on which the animal can sit for considerable lengths of time. Sitting on the mound surrounding

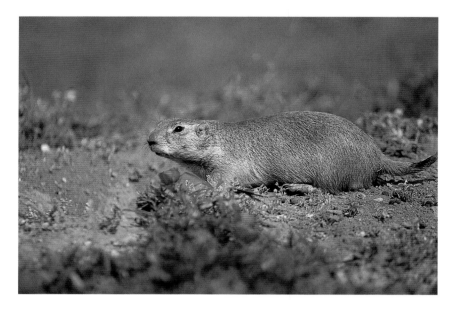

Black-tailed prairie dogs are from fourteen to seventeen inches in length.

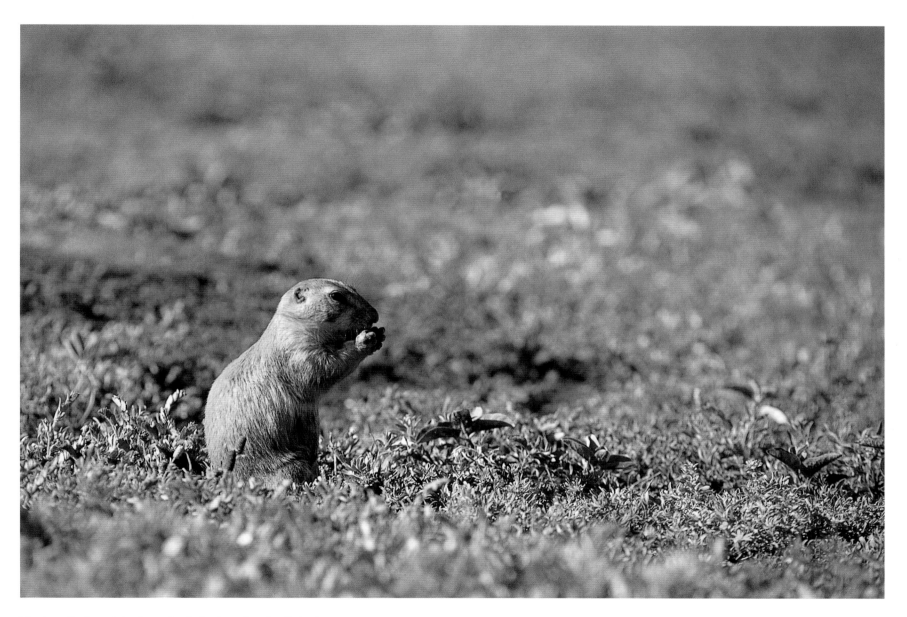

Black-tailed prairie dogs feed during the daylight hours.

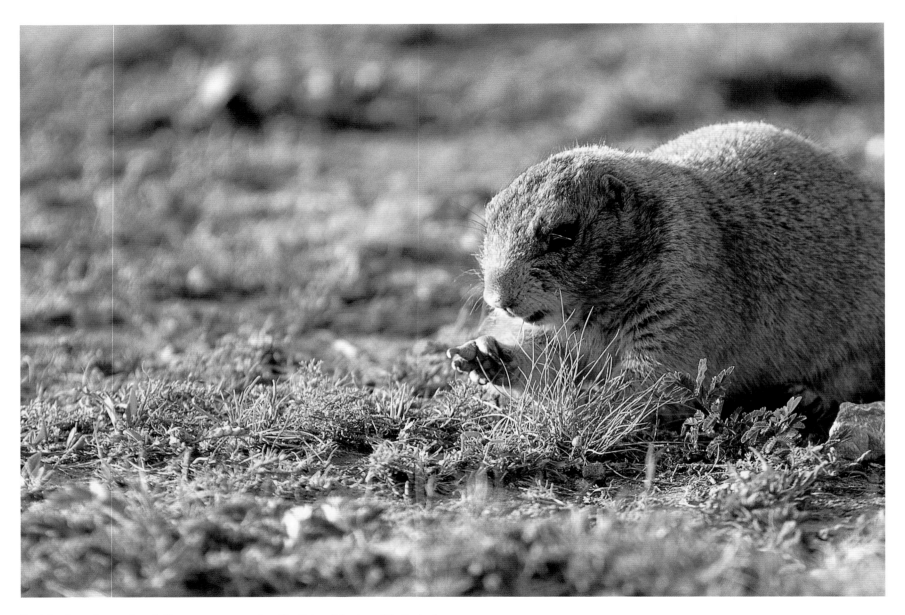

Prairie dogs have the ability to grasp and articulate objects with their forepaws.

its burrow is a prairie dog's duty as a sentry of its colony and a member of its community. Prairie dogs in the sitting position scan the horizon for predators such as coyotes or badgers and are usually the first to sound the alarm when danger approaches.

The paws and claws of the black-tailed prairie dog are also specially adapted. The foreclaws are long and black, with a slight curve. This makes the black-tail an efficient digger in loose and compacted dirt. The forepaws also articulate a great deal, so the dogs are able to grasp plants in order to pull them from the ground and hold them to eat. This enables the prairie dog to carry on the simultaneous chores of watching for danger and ingesting food. The rear claws, although not as long as the foreclaws, are used to help dig, but they function primarily as a means to disperse soil that has been loosened by the foreclaws. This dirt-moving ability is often demonstrated when chunks of soil are hurled from a burrow several inches, if not feet, into the air. Often after such digging a dirty-faced worker will emerge from the burrow panting as if near exhaustion.

The black-tailed prairie dog's current range extends from the Trans-Pecos region of Texas north through southern and eastern New Mexico and the Texas Panhandle to parts of North Dakota, most of Montana, and parts of southern Canada.

The Mexican Prairie Dog

The Mexican prairie dog is the rarest species of prairie dog, and is thought to be the species most closely related to the black-tailed. An estimated 98 percent of its population is isolated in the valleys and prairies of the states of Coahuila and Nuevo León in northeastern Mexico. The remaining 2 percent live in the adjoining state of San Luis Potosí. The common feature of these regions is that they contain grassland habitat and bare soils at elevations between 5,500 and 7,200 feet above sea level. The Mexican prairie dog prefers areas with deep soils lush with short grasses and forbs (broadleaf plants) and free from rocks.

The Mexican prairie dog, like the black-tailed prairie dog, is tan to buff in color with a stippling of black hairs and a black-tipped tail. The main difference between the two species is their size; the Mexican prairie dog is approximately 25 percent smaller than its cousin to the north. Mexican prairie dogs grow to about 15 inches in length from head to tail. The males are slightly heavier, at an average of 2.6 pounds, while the females typically tip the scales at an average of 1.9 pounds.

Mexican prairie dogs prefer to live in colonies broken up into distinct groups. Each family unit is usually made up of two adult males, one to four adult females, and sixteen to

twenty young. A typical colony contains fewer than seven adults and yearlings within an area of about 2½ acres. The Mexican prairie dogs' propensity for clipping the grass around their colony in order to get a better view of their surroundings has gotten them into trouble as a species. Mexican farmers and ranchers consider the rodents an agricultural pest and have systematically poisoned and otherwise exterminated colonies of the dogs. Since 1955, when the decrease in numbers was first reported, the Mexican prairie dog has been reduced in overall numbers by an estimated 62 percent. Under the Mexican Law for the Ecological Equilibrium and the Protection of the Environment, however, private landowners may no longer kill prairie dogs or destroy their habitat.

Mexican prairie dogs, like black-tails, are diurnal and do not hibernate. They are prolific breeders and begin to reproduce during their first or second year, depending upon body weight. The breeding season can begin in January and run through April. Mating depends upon the availability of food, which is a direct result of rainfall. The gestation period is about a month, and females produce an average of four pups per litter once a year. Mothers suckle the pups for forty-one to fifty days before weaning them.

The White-Tailed Prairie Dog

The white-tailed prairie dog, another cousin of the common black-tailed, is found mainly in the mountainous valleys of northwestern Colorado, northern Utah, and western Wyoming at elevations of six to twelve thousand feet above sea level. In color, white-tails have a yellowish coat streaked with black. One of the primary distinguishing characteristics of the white-tailed prairie dog is a blackish-brown spot above each eye and on each cheek. The tail, as the name implies, is white, although some individuals do exhibit some black and light red coloration of the tail hairs. In size, white-tailed males are approximately 20 percent larger than females of the species. On average, the male white-tailed prairie dog is fourteen inches in overall length from head to tail. The tail makes up 14 percent of the total length, measuring two inches long. These animals weigh an average of 1.5 to 2.5 pounds.

Unlike the black-tailed prairie dog and the Mexican prairie dog, the white-tailed prefers areas of tall grass, where it eats various forbs and grasses, such as grama and wheatgrasses, that grow in areas under the forces of ecological succession.[3] Studies have shown that the white-tailed prairie dog's diet consists of 60 to 80 percent of the plant species native to its range and that the dogs do not eat introduced weeds. Range estimates have concluded that high white-tailed prairie

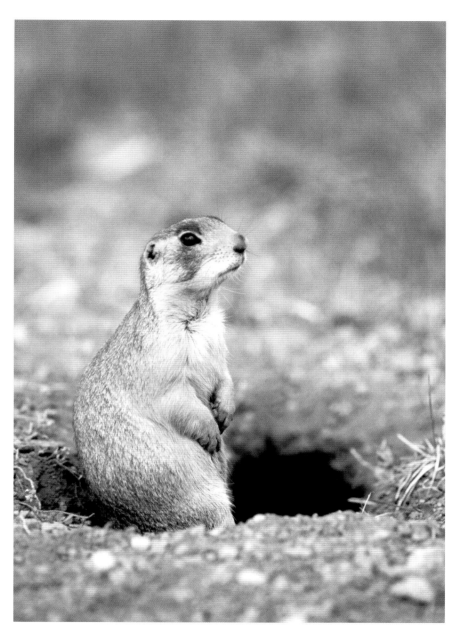

dog populations can be linked to areas where there are few or no introduced weeds. Because the species depends on tall-grass prairies, its numbers decline in areas heavily grazed by livestock.

The white-tailed prairie dog's world is made up of adjoining burrows that loosely resemble a town. White-tailed prairie dogs are far less social than the black-tailed species, and their towns lack the black-tails' tightly structured organization. In areas where they are found, the density of white-tails usually averages one to two adults per acre.

Like the other species, white-tailed prairie dogs spend most of the daylight hours out of their burrows. For the white-tails, though, winter means hibernation. Late August finds the small mammals retiring to their burrows for a long winter slumber. They emerge in the spring, the males being the first to poke their heads out. Soon after emerging from hibernation, in late March and early April, the white-tailed prairie dogs mate. Following a 28- to 30-day gestation period, the female ultimately whelps a litter of from one to seven young. During the 35- to 44-day period of lactation, the only social structure evident in the white-tailed prairie dog community exists between the mother and her young in a single burrow. After the young are weaned, they leave their birth burrow to establish their own homes.

White-tailed prairie dog. (Photo by Ken Ringer)

The Gunnison's Prairie Dog

Gunnison's prairie dog. (Photo by Ana Davidson)

The Gunnison's prairie dog is the smallest of all the prairie dogs. Its head and body average eleven to twelve inches long, while its short tail measures 1¼ to 2¼ inches in length. It weighs in at about two pounds when fully grown, although some individuals are as small as ten ounces.

The Gunnison's prairie dog is more closely related to the white-tailed than to the black-tailed prairie dog and is similar to the white-tailed prairie dog in appearance. It is buff in color with a lighter underside. The main characteristic that distinguishes the two is the lack of a black spot over the eye of the Gunnison's prairie dog. In addition, the Gunnison's tail is usually brown or gray with a white tip instead of all white.

This species occupies about the same amount of range as the white-tailed prairie dog but is found further south, in the Four Corners region of northwestern New Mexico, northeastern Arizona, southwestern Colorado, and southeastern Utah. Like the white-tailed prairie dog, the Gunnison's prefers the tall grasses found in open meadows between stands of juniper and pines in mountain valleys at elevations of five to ten thousand feet. Like other species of prairie dogs, the Gunnison's prefers forbs and grasses, but it also feeds occasionally on small insects, such as grasshoppers.

The Gunnison's prairie dog is more of a loner than are the other species of prairie dogs and does not have an encompassing social and colonial structure. Instead, it lives in loose-knit groups. Its population densities vary but usually average about one to two adults per acre. Burrows are usually dug about 3½ feet deep but have multiple surface entrances. A study of burrows near Prescott, Arizona, showed that one had seven surface entrances and five lateral tunnels that did not reach the surface. The burrow entrances are flush with the surface of the ground and do not have the dirt mound associated with the burrows of the black-tailed prairie dog.

Like its cousin species, the Gunnison's prairie dog is active during the daylight hours—most often early in the day and late in the evening. During the winter it hibernates intermittently during cold spells, emerging in the early spring for breeding. Within the burrow, native grasses and other plants found in the area provide bedding. The female usually gives birth to one to seven young in early May after carrying them in her womb for twenty-eight to thirty days. The young stay underground to suckle for about five weeks before they finally emerge.

The Utah Prairie Dog

The Utah prairie dog is the rarest of the four species of *Cynomys* found north of Mexico. Located in only five counties of southwestern Utah, this rodent was added to the Endangered Species List in 1973. Because of management, protection, and restocking efforts by both state and federal wildlife agencies since that time, however, populations of this prairie dog have increased. Still, in the year 2000 the Utah prairie dog numbered only about two thousand in the wild.

A distinguishing characteristic of the Utah prairie dog is its geographic limits—the high mountain valleys of southwestern Utah. Because its range does not overlap that of any other prairie dog species, it is rarely misidentified. In these valleys, from six to twelve thousand feet above sea level, the Utah prairie dog searches for areas of deep, well-drained soils in which to burrow. Often these soils provide a variety of tall grasses and forbs that a Utah prairie dog prefers in its diet, primarily through the summer months.

A close relative to the Gunnison's and white-tailed prairie dogs, the Utah species is similar in both appearance and size: buff in color with a white underside, a white-tipped tail, and a black spot over each eye. These prairie dogs grow from twelve to sixteen inches in length and weigh 1½ to 2½ pounds when they reach adulthood.

Mating among the Utah prairie dogs generally occurs in March, after a winter's hibernation in the burrow. Individuals over one year of age are the primary breeders in the colony and typically produce a litter of one to seven young after a twenty-eight- to thirty-day gestation period. The young usually stay below ground for six weeks before they begin to emerge from the burrow to forage on grasses.

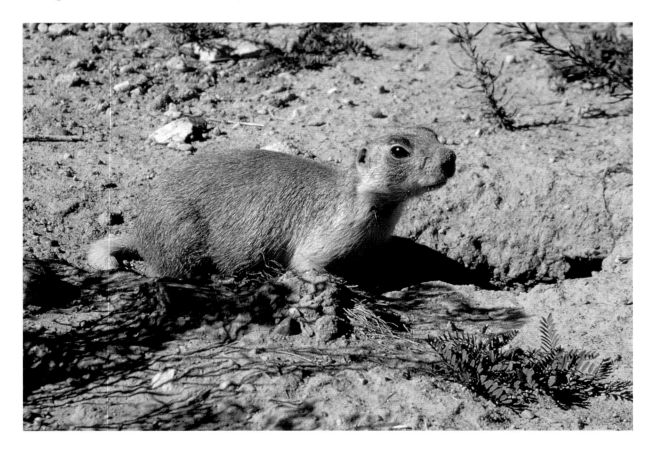

Utah prairie dog.
(Photo by Ana Davidson)

Habits and Biology
of the Black-Tailed Prairie Dog

The black-tailed prairie dog may be the one of the liveliest animals in North America. Its constant antics—wrestling, chirking, calling, digging, and sitting up scanning the horizon—make it an endearing creature. The many and varied activities of the prairie dog look like an extended play-period to the novice observer, and its high level of socialization—incessant chattering, running from burrow to burrow, and "kissing" when greeting others —gives it almost human qualities. These activities and habits compose a complex set of behavioral and social patterns that make the black-tailed prairie dog unusual among animals.

Life in the Burrow

The one element that characterizes the prairie dog on the western prairie is the great number of burrows that make up a prairie dog community. The prairie dog colony is hole after hole, as far as the eye can see, with prairie dogs distributed randomly, sitting atop various holes searching for danger or eating grass. Unfortunately for the prairie dog, these features of its colonial life create the most problems for the animal. The most common worries of the stockmen and farmers who have historically sought to eradicate the rodents are that prairie dogs destroy crops, compete with livestock for grass, and dig holes into which livestock can fall and be injured.

For the prairie dog, the burrow is the center of all activity within a family unit as well as the entire colony and serves as the animal's only means of shelter from the elements and predators. The prairie dog creates its own habitat. It is able to transform an area of marginal habitat into an area that suits its every need. This transformation starts with the process of burrowing. When a dog starts to work on the visible portion of a burrow, the hole is usually about six inches to a foot in diameter on the surface. As the dirt from the burrow begins to collect around the outside of the hole, prairie dogs often work vigorously to shape, repair, and maintain the cone. Often several workers can be seen working on a burrow mound at the same time.

John Hoogland, professor of biology at the University of Maryland's Appalachian Laboratory, has spent sixteen years studying the black-tailed prairie dog at the Wind Cave National Park in South Dakota and has recorded a detailed account of the rodent's life. According to Hoogland, distinct types of burrow craters can be found within a prairie dog town. The first type of mound is generally flat, with no noticeable grade. These burrows are found around the periphery of a colony and are used primarily as emergency escape burrows and as temporary shelters during midday heat.

Burrow entrances with wide, unstructured mounds of dirt around them are called dome craters. Dome craters are generally two to three feet in outside diameter and are generally four to five inches tall. Prairie dogs use dome crater burrows to escape predators, sleep at night, and raise their young.

Burrow mounds with rim craters are the tallest and most conspicuous of all the mounds. They are structured mounds of packed dirt that take on the classic cone shape of a volcano. The outside diameter of rim craters is three to three and a half feet, and they can be as tall as three feet. Prairie dogs use rim crater burrows in the same way they use dome craters.

The mound also serves three basic functions for the maintenance of the burrow and the colony at large. First, it

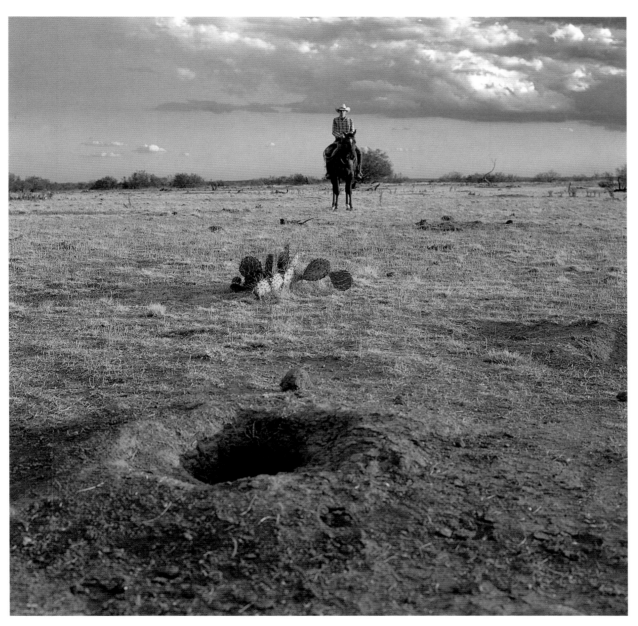

A common concern of many ranchers and farmers is that their livestock may be injured by stepping into a prairie dog burrow.

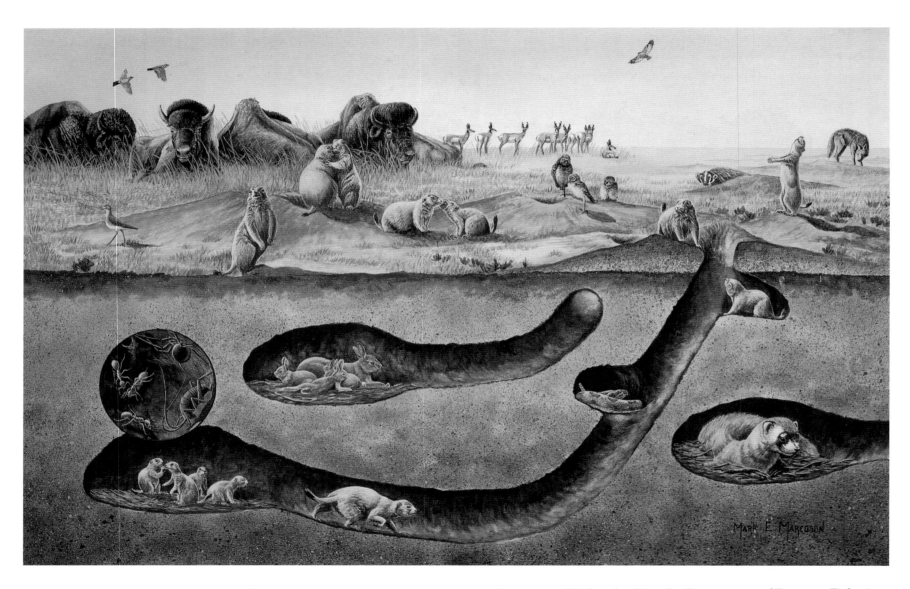

Cross section of a prairie dog burrow. (Drawing by Mark E. Marcuson; courtesy University of Nebraska–Lincoln, Department of Forestry, Fisheries, and Wildlife)

serves as a dike. During inundating downpours, the mound serves as a mechanism for inhibiting water flow into the burrow. Second, the dirt mound serves as an elementary watchtower for the prairie dog. Because one of the main defense systems of the prairie dog is sharp eyesight, the burrow mound gives a sentry a little extra elevation from which to keep watch over the surrounding prairie for any hint of danger. Third, the burrow mound helps create a draft that circulates fresh air through the burrow chamber to cool off the inhabitants. When a breeze blows across a dome crater connected underground to a higher-rimmed crater, reduced air pressure in the lower crater pulls fresh air into the burrow. Even a slight breeze will cause the circulation.

As the burrow descends, the opening of the tunnel narrows to about five inches in diameter. The type of soil in a prairie dog's home range governs the depth of the burrow. In tight soils the burrow may descend a few feet deep, but in loose dirt, prairie dogs have been known to burrow as deep as fifteen feet or more. On average, the burrows extend laterally underground for twenty to thirty feet. Within this span, the prairie dogs construct many chambers to serve their family's needs.

Within a family group's home range, several burrow mounds connect to each other underground. Such a family group, known as a coterie, is generally made up of a breeding male, three to four females, and several yearlings and juveniles who are nonbreeders. Each family group is responsible for maintaining and defending its territory from intruders and from neighboring groups. A colony, or town, made up of adjacent coteries, can span many acres.

Within a coterie territory, which covers about an acre in size on average, there are as many as fifty to one hundred different burrow entrances. Most burrows have only one or two entrances, but some have as many as six. This is probably a result of a family group's using the burrow over a number of years and building new tunnels to accommodate its needs. Contrary to popular belief, neighboring coteries do not connect their burrows to create a massive network of underground chambers. Instead, members of a coterie vigorously defend their burrows from neighboring coteries. Adults in the coterie, and less often juveniles, carry out maintenance chores, such as constructing rims, carrying nest materials into the burrow, or clearing dirt out of existing burrows.

Underground, conditions are comfortable year-round. On average, temperatures in the burrows range from 41 to 50 degrees Fahrenheit in the winter and 59 to 77 degrees during the summer, with an average relative humidity of 88 percent.

A prairie dog burrow generally consists of a nest chamber, listening chambers, and sleeping quarters. Nest chambers are used as a place to give birth and to rear the young until they are weaned and leave the parents' burrow. The nest, which is packed into an egg shape about sixteen inches wide and twelve inches high, is made up of plant materials found in the

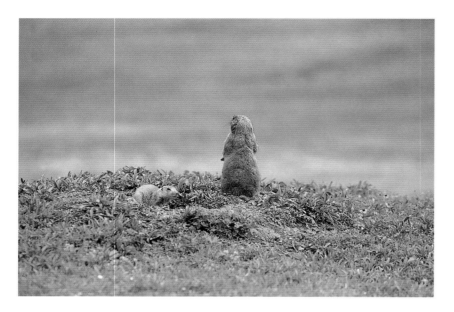

A flat burrow entrance.

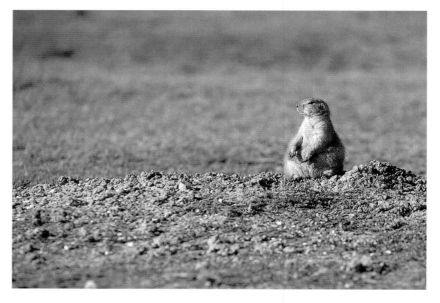

A dome crater entrance mound.

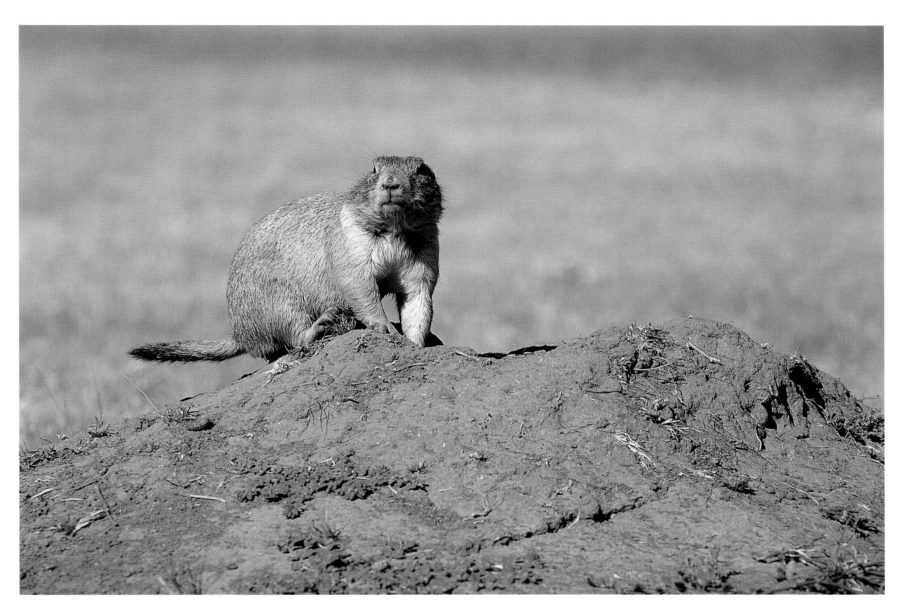

A rim crater entrance mound.

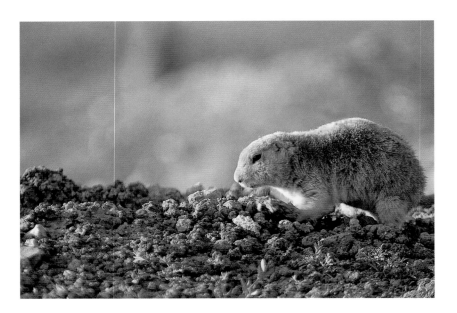 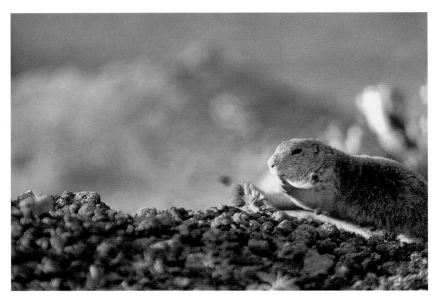

Prairie dogs are very efficient dirt movers, displacing nearly five hundred pounds of soil from each burrow they dig.

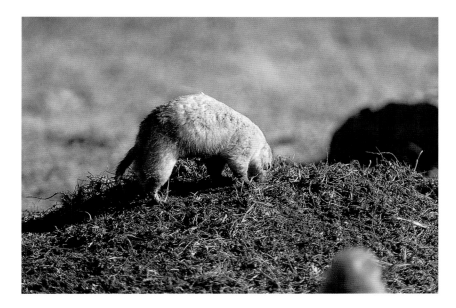

This prairie dog is packing down the soil of its entrance mound.

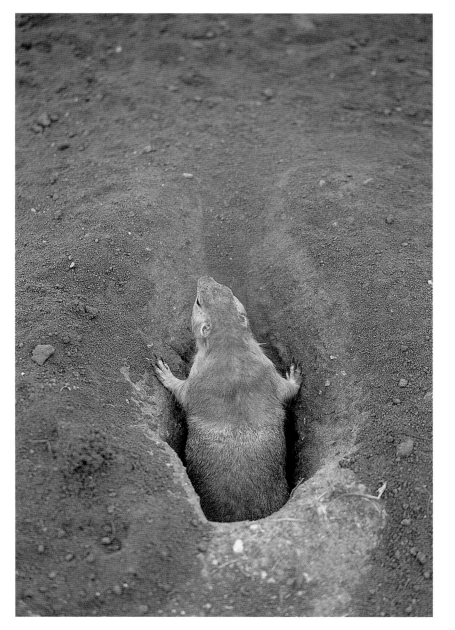

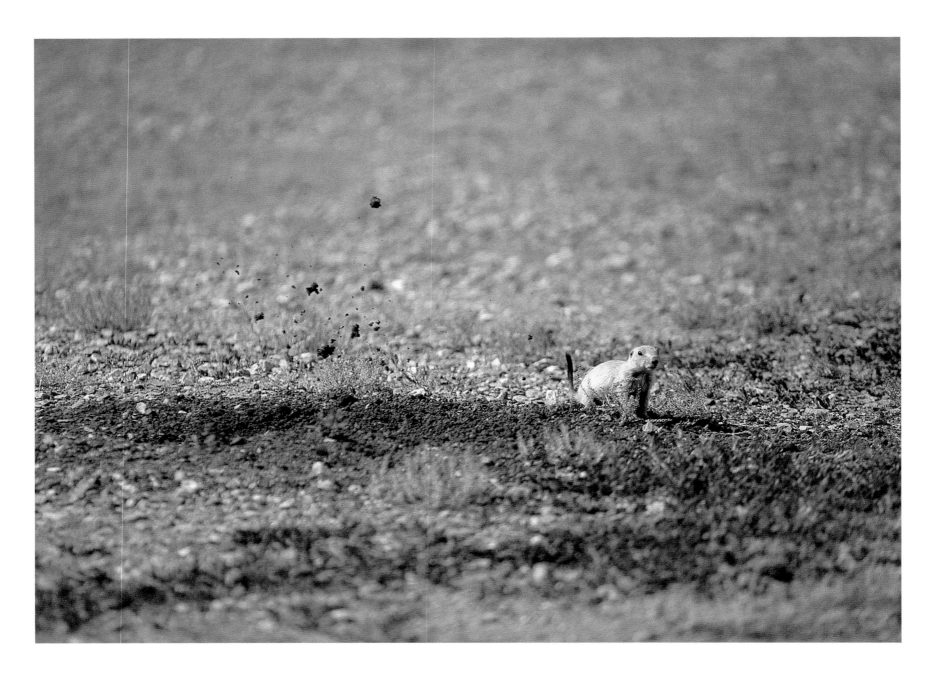

The Prairie Dog

Prairie dogs often stay just below the burrow entrance to listen for predators.

area. Females who are raising unweaned young will often plug all but one entrance to the nest chamber. Researchers think this activity is intended to reduce predation on young by other prairie dogs and animals of different species. By having only one entrance to her nest, the mother can defend her young more effectively.

Circular listening chambers, located approximately three feet below the surface, are used when prairie dogs scamper below ground during the day to escape predators. The animals will remain in the chamber, listening intently for aboveground activity, until they are signaled by another member of the colony that all is clear or until they cannot hear intruders overhead. Other chambers filled with grassy nests are used by adult prairie dogs as sleeping quarters.

There is some debate whether the prairie dog has a specific spot underground that it uses as a latrine. Some researchers who have excavated burrows suggest that a higher incidence of feces in particular areas shows that the prairie dogs use that particular area for defecating. Other scientists, however, conclude that the dogs defecate underground wherever they wish and then carry the feces above ground for disposal. In either case, this practice is unusual, and prairie dogs usually defecate above ground.

Food Habits

Aside from the perceived nuisance that the black-tailed prairie dog causes by digging holes for its burrow, critics also attack it for what it chooses to eat. Reports completed in the early twentieth century concluded that thirty-two prairie dogs consume as much grass as one sheep, and 256 prairie dogs eat as much as a cow. These reports set in motion a war on prairie dogs and solidified attitudes that still exist today. The reports, however, have proven to be false. A prairie dog's diet consists of some of the same grasses that a bovine eats, but the two animals' diets do not overlap completely. Prairie dogs by nature and biology are not true herbivores. Instead, they are omnivores who eat mainly grasses and forbs but also occasionally consume some insects, such as grasshoppers, within their home range. The typical diet of a prairie dog is dependent on the season. Winter finds the dogs consuming prickly pear cactus pads, thistles, and plant roots. In summer they eat wheatgrass, gramas, and buffalograss.

Prairie dogs get their water from the plants they consume. Naturalist J. R. Mead first noted that prairie dogs do not get water by conventional means. "Not a drop [of water] could be found within several miles [of a prairie dog town] and none by digging above the rock, and not a particle of dew fell for weeks in the heat of summer," Mead wrote. "The scant grass

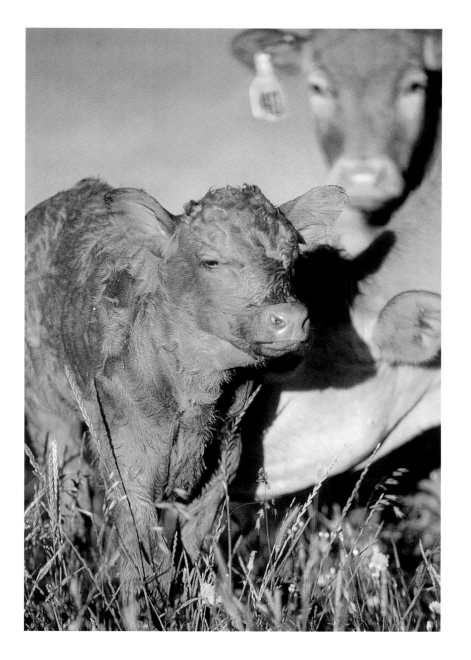

was dry enough to burn an hour before sunrise; and I was forced to the conclusion that nature had constructed an animal capable of living long times without water." Studies in Montana have confirmed Mead's assumptions. A prairie dog can go for six weeks or more during the summer months without food or water. In doing this, the dog lives off its fat reserves and loses as much as 50 percent of its body weight, all the while remaining active—a feat that would kill other animals. The prairie dog survives by retaining its blood sugar and recycling nitrogen in its body.

Prairie dogs commonly eat by clipping the vegetation at ground level. Often, however, they simply eat the tops of plants. This serves as a means of keeping the town clear of any vegetation that may obstruct the prairie dogs' vision (their first line of defense) and thus lessening the chances that a predator can sneak up unnoticed. Studies have shown that in new areas of colonization the canopy height of the grass is reduced by 62 percent within two years.

When a coterie of prairie dogs clips the vegetation from within its range, several interesting things happen. The soil temperature in the area rises, making seed propagation more

It was once suggested that 256 prairie dogs consume as much grass as one cow.

Habits and Biology of the Black-Tailed Prairie Dog

difficult for some species. The clipping of plant species within a colony by prairie dogs also promotes a decrease in plant biomass, changes from grasses to forbs in the overall makeup of the range, and a higher silicon concentration in forage plants. The last occurs because of a genetic mutation that some forage grasses go through in order to make themselves less palatable to grazers. The constant cutting of the grasses sets back the natural progression from grassland to steppe prairie. Therefore, in areas with heavy prairie dog activity, short-lived forbs, annual grasses, prickly pear, and shrubs replace perennial grasses. Clipping the grass helps a prairie dog make more efficient use of feeding time because it gets more grass at once and has to make fewer trips away from the safety of the burrow. On average, a prairie dog will rarely go beyond thirty feet from a burrow. When a prairie dog collects dried grasses for its burrow, it will carry them in its mouth back to the hole. After grabbing a bite of grass or forb, the prairie dog will either eat it with one forepaw while standing on three paws or it will sit up on its rear and manipulate the plant with both forepaws, simultaneously nibbling and watching for predators.

Although farmers and ranchers often see the prairie dogs' occupation of range as all negative, research concerning prairie dogs' effects on range health and range use by cattle is contradictory. For example, one study conducted by R. Hansen and I. Gold in 1977 suggests that stocking rates in their test area could have been 58 percent greater if no prairie dogs had been present. Yet another study by M. E. O'Meilia, F. L. Knopf, and J. C. Lewis in 1982 indicates that weight gains in pastures with and without prairie dog towns show no statistical differences—presumably because of the positive effect that prairie dogs have on range herbage.

In 1902, C. H. Merriam erroneously concluded that a prairie dog town in West Texas with an estimated population of four hundred million dogs consumed an amount of forage that would support 1,562,500 head of cattle weighing one thousand pounds each. From that he calculated that 256 prairie dogs consume as much grass as one cow. Studies done in the ensuing years show that this number is wrong. Using more controlled situations and a closer adherence to scientific method, researchers have established that a prairie dog eats about twenty-five pounds of dry grass per year. By contrast, a grown cow eats about thirty pounds of dry forage per day. So Merriam's numbers should have stated that it takes 429 prairie dogs to consume as much grass as one cow eats in a day.

To put that in perspective, the typical black-tailed prairie dog population density is about four adults per acre. According to work done by Taylor and Loftfield in 1924, Kelso in 1939, and Koford in 1958, it would take a prairie dog town of 107.25 acres to consume as much grass in one day as one cow eats in the same time. In debates about the prairie dog, however, Merriam's old standard is still quoted when anti–prairie dog sentiment is expressed.

Prairie dogs are omnivores and sometimes eat insects such as grasshoppers.

Habits and Biology of the Black-Tailed Prairie Dog

Prairie dogs feed on a wide variety of plants, such as buffalograss, prickly pear cactus, sideoats grama, and plantain.

The Prairie Dog

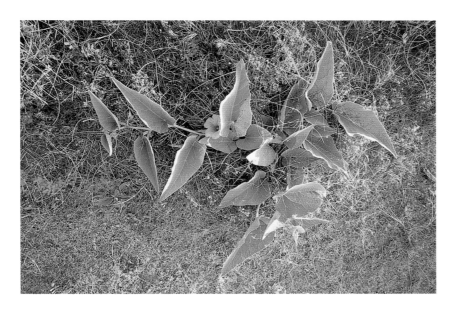

Hairy grama, verbena, buffalo gourd, and milkweed are among the plants commonly found in prairie dog towns.

Another debate is whether prairie dogs help improve rangelands. According to many contemporary scientific views, the prairie dogs' constant digging and burrowing help improve the humus matter in soil by incorporating fecal matter and dead grass. This mixing of the soil helps to aerate it and reduce soil compaction in the upper profile of the topsoil. Scientists suspected that the increase in organic matter, along with the increased water intake that the loose soil promotes, helps the ground retain more moisture, thus increasing the productivity of the shortgrass prairie the rodents inhabit. Prairie dogs help increase plant diversity by improving soil conditions and selectively harvesting plants.

Another benefit discovered by scientists is that the soils in prairie dog towns are richer in nitrogen and phosphorus than those of adjacent rangelands where prairie dogs are not present. Nitrogen, the elemental building block of protein, is responsible for growth and green-up in plant communities, while phosphorus stimulates root growth, energy production, and photosynthetic conversion in plants. This benefit occurs when a prairie dog removes aging leaves from plants. Old and mature leaves are lower in nitrogen and overall digestibility. When a prairie dog removes them, the pruning allows new growth, which in turn is higher in nitrogen and digestibility. Furthermore, prairie dogs have been shown to control mesquite trees effectively. It is thought that the dogs eat the mesquite beans and young plants before they get a chance to

Prairie dogs use oldfield three-awn for nesting material.

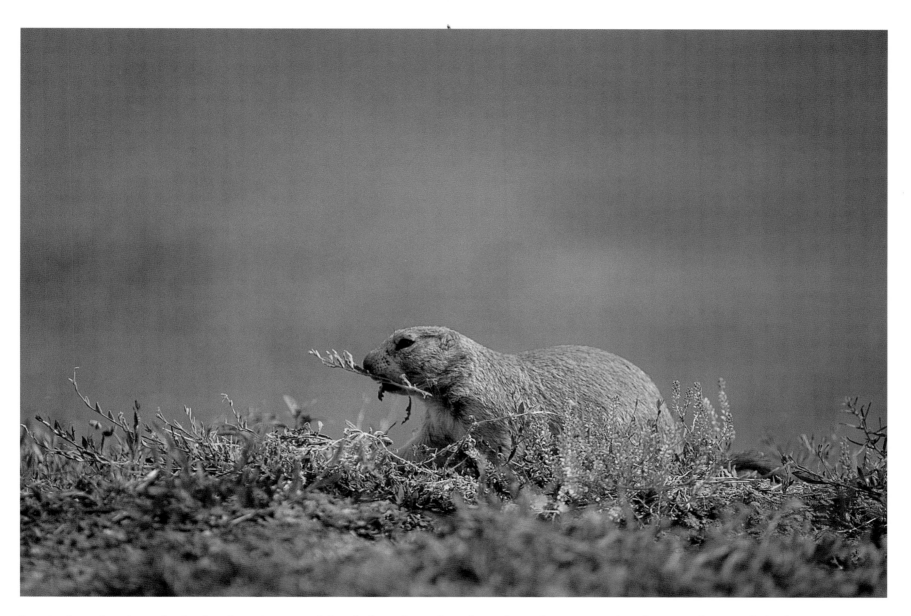

Prairie dogs clip plants for food and nesting material and also to keep the colony clear of any vegetation that may obstruct their view.

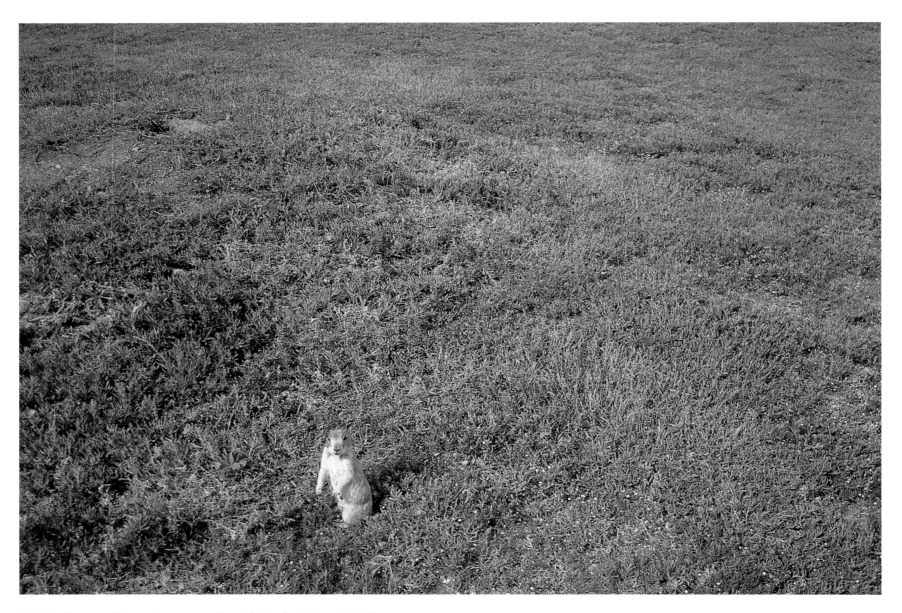

Prairie dogs rarely venture more than thirty feet from their burrow.

The Prairie Dog

mature beyond control. Ultimately, proponents of prairie dogs argue that they are not much of a detriment to the prairies. After all, the prairie dog supported an immense ecosystem of bison, pronghorn antelope, and a healthy number of predators for thousands of years.

The Voice of the Prairie Dog

One of the first times I ever saw a prairie dog town, I was taken aback by the constant chattering, calling, running, and scurrying in which prairie dogs engage in their everyday life. As I surveyed a small town on the Oklahoma prairie with a pair of binoculars, a chain reaction took place before me. First, without warning, one prairie dog stretched its body from the edge of the mound toward the blue sky overhead, making a shrill call. After the first dog made the call, one after another copied it. Then they returned to the usual activities of the town: members greeting each other with a kiss, mothers grooming their young, and juveniles wrestling and playing as young human children might. This was a perfect example of the prairie dog's animated and comical habits, which account for its popularity in contemporary culture.

The prairie dog uses a complex system of both vocal and nonvocal communication to "talk" to members of its coterie and others in a colony, in much the way many other social animals use different sounds, voice inflections, and body language to suggest meanings and apply them to various situations. Researchers have documented twelve different verbal calls as part of the prairie dog's lexicon. These calls are meant to serve a variety of purposes, such as warning others in the colony against predators, attracting a mate, calling for aid as a

territorial dispute erupts, or letting the colony know that a predator has left the area and that all is clear.

The primary verbal call in the arsenal of the prairie dog in its constant defense from predators is the antipredator call. This call consists of a series of "chirks" that the warning dogs emit as a predator, such as a coyote or badger, draws near. Often, the chirk will increase in frequency as danger approaches. When giving the antipredator call, a prairie dog will often crouch low in the top of its burrow, its head barely visible above the peak of the rim of the burrow and its short tail sometimes flicking in rhythm with the call. Prairie dogs often adopt other postures as they warn of danger. An observer can also hear the antipredator call while the prairie dog is sitting up or standing on all fours, for example. When it sounds the call, however, the dog is seldom more than a couple of feet from a burrow opening.

It is interesting that only about 50 percent of the prairie dogs within a coterie give the antipredator call, although the call stimulates other dogs to begin calling before they have spotted the intruder. Moreover, a prairie dog will only initiate an antipredator call about 40 percent of the time when an intruder is in a foreign coterie's territory. When such a call

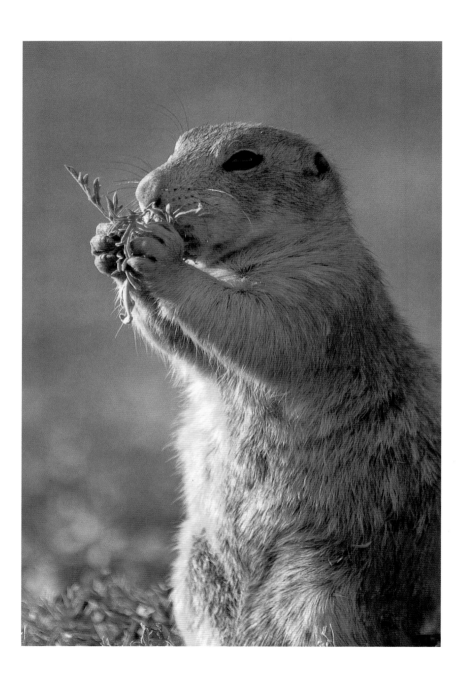

By sitting upright while they eat, prairie dogs can also watch for predators.

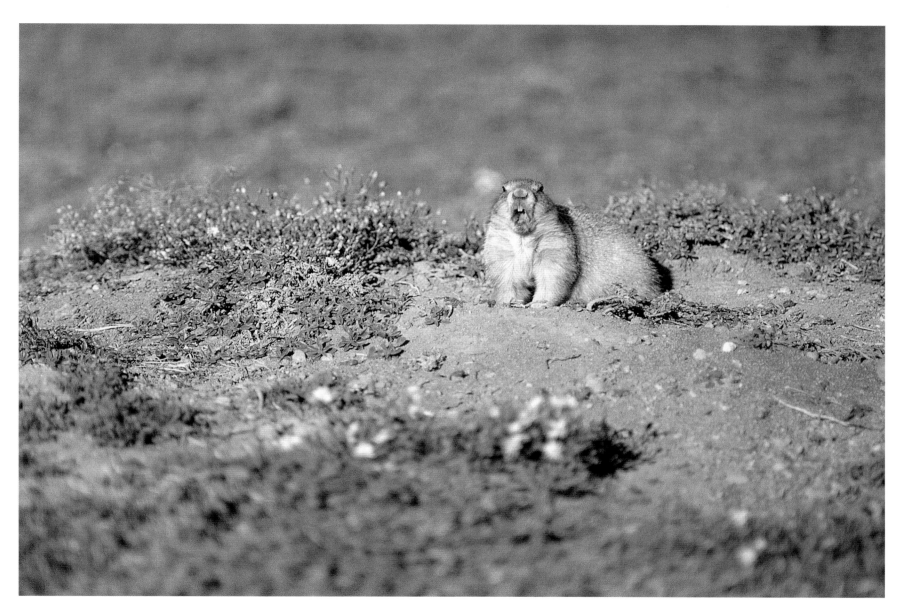

Researchers have documented twelve different vocalizations as part of the prairie dog's lexicon.

Prairie dogs take many postures when alerting to danger.

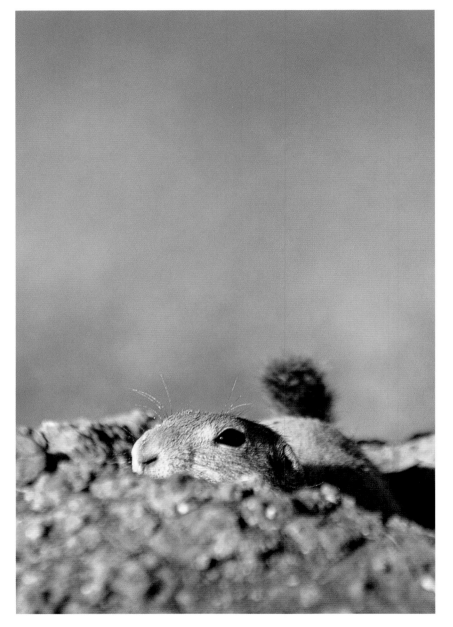

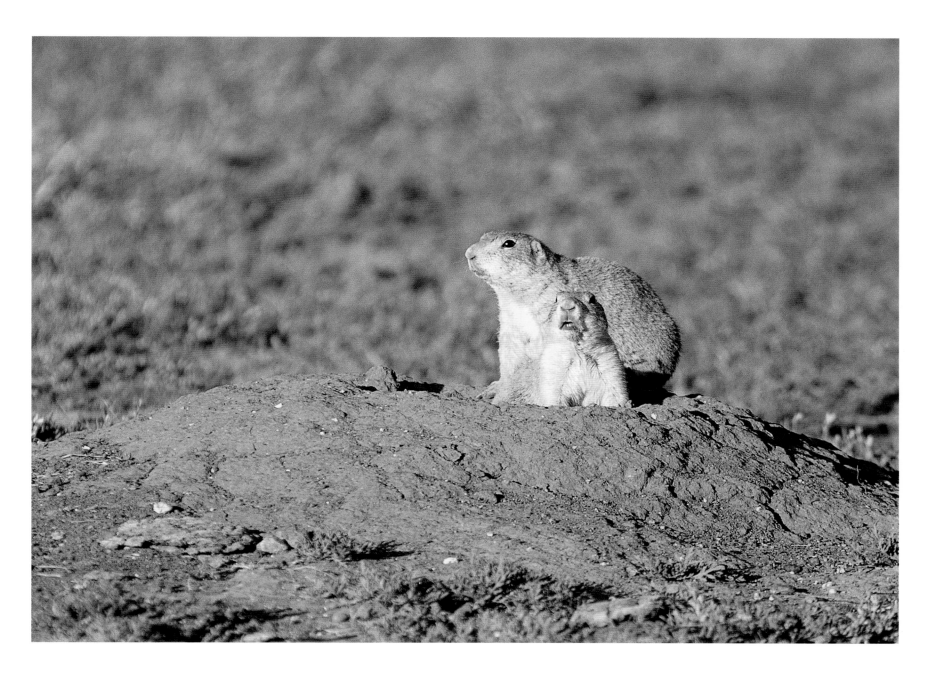

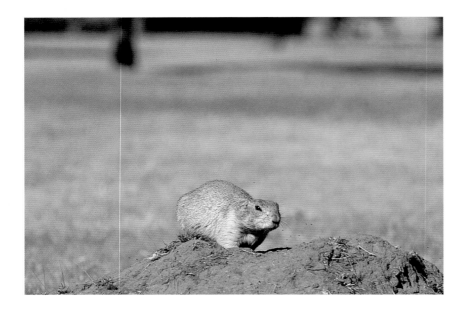

A prairie dog makes a quick escape as danger approaches.

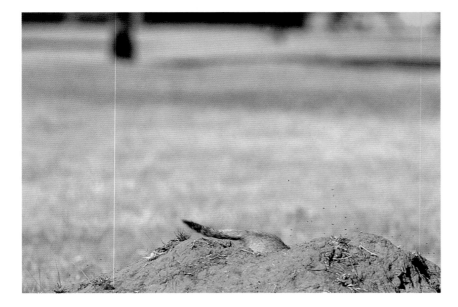

sounds, the other prairie dogs within earshot will stop what they are doing to locate the source of the aggravation. If a predator is not directly threatening or passes by the coterie, the dog will return to foraging. More immediate threats cause it to retreat to its burrow and sit just below the ground, watching and waiting. It is only when a predator comes near—sometimes as close as five feet away—that the dog will scurry further down into its hole.

The reason for this behavior is that, by remaining aboveground, the dog can keep an eye on the predator. If the intruder, such as a coyote, passes through the coterie and leaves for good, then the prairie dog can go about its business of foraging once more. If a prairie dog dives underground at the first sign of danger, then that individual has no way to see if the danger has passed or is waiting silently overhead. The only way to find out would be to go aboveground and investigate—and that could prove fatal.

The call most closely associated with the prairie dog in many people's mind is the jump-yip. The jump-yip begins with a prairie dog on all fours. Then, without warning, it will fling itself up on its two back feet while throwing its head back and forefeet out perpendicular to its body. At the apex of its upward movement, the prairie dog lets out a "wee" sound, followed by an "oh" sound as the dog returns to all four feet—all the while with its eyes closed tightly. After the first prairie dog gives a jump-yip signal, others quickly join in to relay the message across the threatened portion of the colony. Observers have thought that the jump-yip serves as an "all-clear" call, used only to signal other prairie dogs that the threat of a predator has passed and that they can go back to their usual activities. The jump-yip has been witnessed consistently after attacks of terrestrial and avian predators. Studies have shown, however, that prairie dogs also jump-yip during territorial disputes with members of other coteries and under other nonspecific situations unrelated to predators.

Other calls in the prairie dog's repertoire include mating purrs and the defense bark. The defense bark is used during territorial and mating disputes, and females often use it in an attempt to summon help from family members, mainly males.

Recent research suggests that prairie dogs' vocalizing may be quite complex, with the capability to identify predators and communicate with other prairie dogs in ways adapted to the colony's surroundings. Con Slobodchikoff, a biology professor and researcher at Northern Arizona University, recorded the antipredator calls of scores of individual prairie dogs over a ten-year period, and found that different sounds were used to identify different predators, such as hawks, coyotes, and humans. Furthermore, vocalizations could change over time in response to their experience with a particular predator; for example, after an experience with a person shooting a gun, the colony reacted differently to humans.

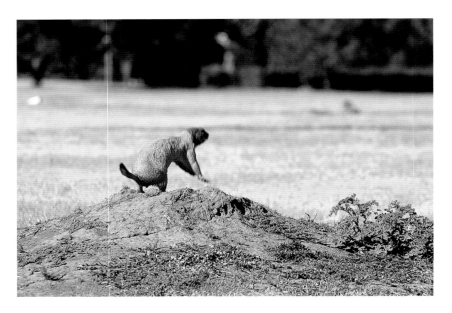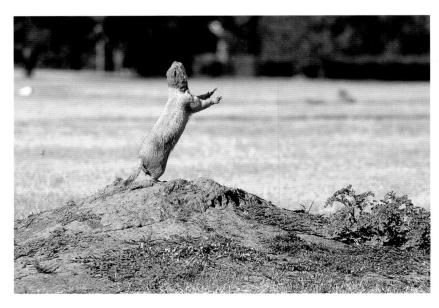

The jump-yip. This call happens so fast and is so unpredictable that a fast camera is essential for capturing it.

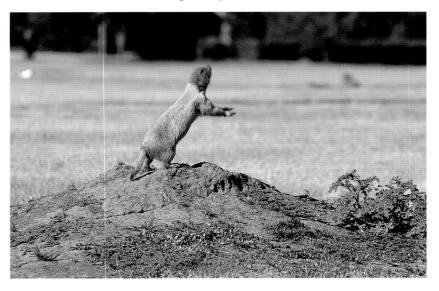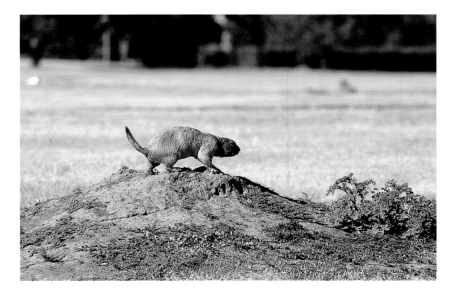

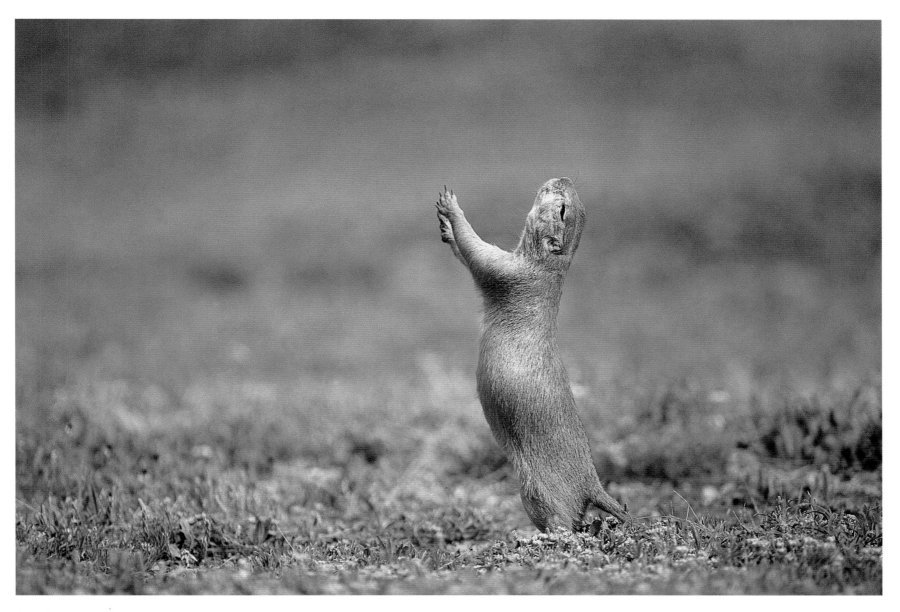

Another view of a jump-yip.

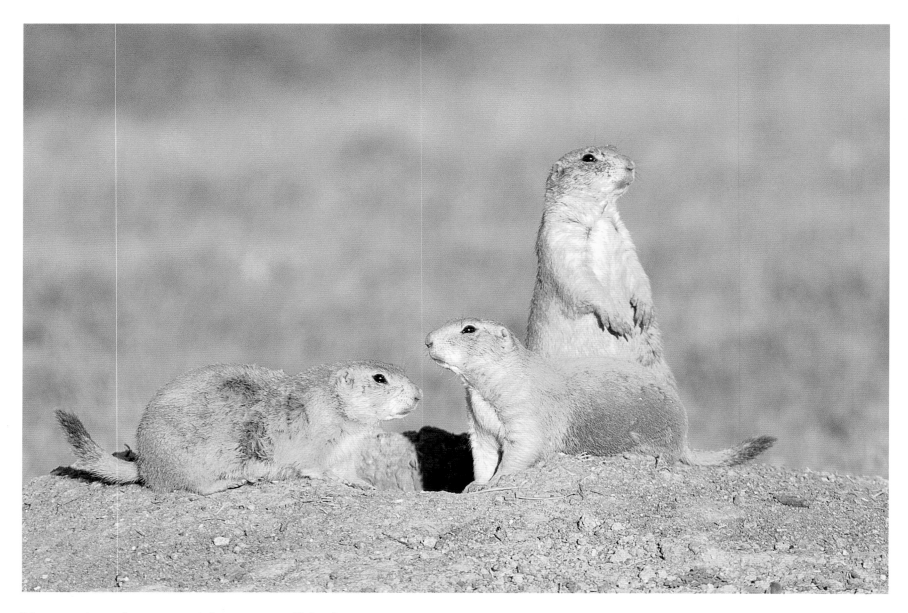

More eyes in a colony can spot danger more efficiently.

The Home Range

Black-tailed prairie dogs are well adapted for life in a colony. As the old saying goes, there is strength in numbers. Nowhere is this more evident than in a prairie dog town. Although prairie dogs exhibit territorial behavior against individuals from neighboring coteries, the complex social order of the prairie dog town is structured so that the group's survival and well-being are more important than an individual coterie or single dog.

Territorial disputes ensue when a member of a coterie enters another coterie's home territory. These turf battles begin with vocalizations of feigned aggressiveness, followed by defense posturing, such as flaring the tail, bluffing a charge, or staring at the rival prairie dog. Vocalizations usually involve chattering of teeth, and, if a female is involved, sometimes a defense bark. When a fight ensues, individuals chase each other, engage in mouth-to-mouth sparring, and sometimes jump vertically into the air. Disputes commonly last as long as thirty minutes until one of the aggressors gives up and runs away.

 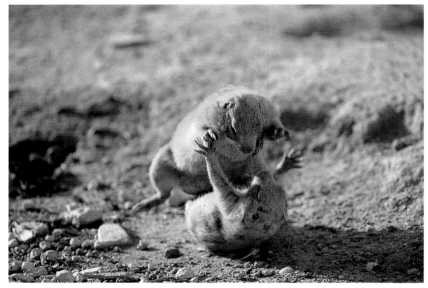

When a member of one coterie intrudes on another, a skirmish often ensues.

The Prairie Dog

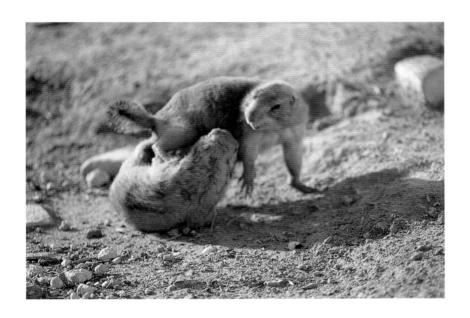 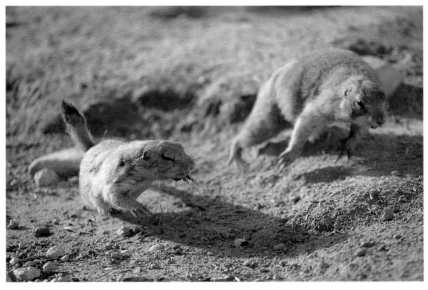

Why do prairie dogs colonize? Many studies have tried to answer this question. R. D. Alexander, in his study of the evolution of social behavior, suggests that animals colonize for three basic reasons. First, colonization makes it easier for group animals, such as wolves, to find food. Colonization occurs in some species when they are forced to live together because of lack of suitable habitat. The last reason—the reason prairie dogs are thought to colonize—is for protection against predators. This concept is simple. More pairs of available eyes are apt to spot predators more easily, thus ensuring the long-term survival of a colony.

Scientists believe a related adaptation has evolved as an attempt to confuse predators. Upon spotting a predator, only a few of the town's individuals initiate the antipredator chirk. The adaptation works like this: A predator, such as a swift fox, enters the town and focuses on an individual prairie dog. As one dog sees the fox, it initiates the antipredator chirk, and members of its coterie and some neighboring coteries become alert. Others, although not all, begin to chirk. Now, instead of being focused on one prairie dog, the fox becomes aware of several, because they are making themselves noticeable through their calling. This awareness of more prairie dogs may distract the fox from its initial goal and cause it to run after another prairie dog, then another and another in a state of increasing confusion. When the scenario plays out, the fox gives up and tries for an easier meal somewhere else.

Prairie dogs also have been documented "ganging up" on other animals as a means of defense. Many old-time accounts describe prairie dogs harassing rattlesnakes to the point of biting at them and sometimes even burying the snakes alive in a burrow. This behavior is the direct result of living in a colony with other dogs in the immediate area. Colonial life also provides other benefits for the prairie dog besides a solid defense. It could be a way of using suitable habitat. As habitat becomes scarce because of factors such as geography or human intervention, the ability of prairie dogs to live in close quarters can benefit the species as a whole. Prairie dogs are able to capitalize and concentrate their survival efforts on small parcels of land. Doing so makes reproduction and, hence, survival more efficient than if the animals were spread out at a lower density. As pointed out, individual, isolated prairie dogs are more susceptible to predation than groups of dogs.

Another advantage of living in colonies is that a large number of burrows are available. Because burrows are the ultimate source of shelter from the weather and predation, a high number of individuals within a colony should guarantee that there is always a hole nearby that an individual can duck into should danger arise. Each dog digs or maintains an average of five burrows, meaning that a coterie of five individuals would have access to twenty-five burrows, thus increasing their chance of escaping from a predator.

Fleas, which often infest prairie dogs, are the vector for bubonic plague.

When plague sweeps through a town, most of the prairie dogs ultimately die.

As John Hoogland points out in his book, *The Black-Tailed Prairie Dog,* however, benefits of living in colonies do not come without tradeoffs. The first and perhaps most devastating is the transmission of ectoparasites, such as ticks and fleas, and diseases such as bubonic plague. Bubonic plague, or sylvatic plague, as it is sometimes known, can devastate entire colonies, passed from one individual to the next by its major carrier, the flea. In one case of sylvatic plague in the summer of 1995 in north central Montana, 70 percent of the prairie dogs died. The prairie dog is also considered an amplifier of the disease. That is, the dogs often get it from fleas but transmit it to other animals, such as humans. Therefore, in some places, anti–prairie dog sentiment is fueled for a third reason.

In the same summer of the big prairie dog die-off in Montana, a sixteen-year-old girl from Colorado contracted bubonic plague and died from it. As the numbers show, she was not the first in Colorado to suffer from the disease. Since 1957, more than forty Coloradans have contracted it. Although there have been some high-profile cases of bubonic plague in the past few years, experts contend that contracting bubonic plague from prairie dogs directly or indirectly is extremely rare.

Another downside to forming colonies, according to Hoogland, is that it increases aggression toward prairie dogs from neighboring coteries. This aggression affects the prairie dogs on three levels. First, it causes losses in time and energy. He points out that one winter day he observed two pregnant

females engaged in a territorial dispute that lasted for six hours. On the second level, aggression subjects prairie dogs to a greater risk of becoming prey. While fighting and chasing each other, they are less watchful and more susceptible to being caught and killed by a variety of predators, such as coyotes and hawks. The third reason aggression is detrimental to prairie dogs is that individuals are injured and subject to infections from fighting during territorial and mating disputes. After the breeding season is over, facial scars are common among males.

Life in colonies also brings about an increased probability that parental care will be misdirected toward offspring of other females. Solitary animals such as badgers rarely mistake others' young for their own and avoid misdirected parental care. Among prairie dogs, however, such misdirection of care is common as mothers mix their young in the dens or when the young emerge from the den in late spring and mingle with others from the same coterie.

A final cost of colonial life is that the benefit of having many eyes to watch for predators also means that there are more individuals to be conspicuous and attractive to predators.

The Social Order

Prairie dogs are vocal animals and spend much of their day vocalizing as they play and groom each other. Prairie dogs also use nonvocal communication with each other, the most noticeable form of which is "kissing." When one prairie dog meets another, they put their mouths together, probably searching for a scent that emanates from a gland in the mouth. This scent recognition helps members of the same coterie recognize each other and helps them avoid territorial conflicts with rival coteries. Practicing the kissing ritual, a prairie dog can tell kin from nonkin.

Female prairie dogs associate with all other females, regardless of the degree of kinship, amicably. Males, as has been described, are friendly only toward close kin, such as sons, fathers, and brothers, treating distant kin with the same animosity that they show individuals that are not kin. Prairie dogs also exhibit subtle dominance hierarchy within the coterie. Reproductive adult males exhibit dominant behavior, which is thought to help ensure reproductive success by the strongest and biggest male, earning him the right to breed and pass on superior genes through the process of natural selection. Nonbreeding males, such as juveniles, do not try to exert dominance over one another, and within the coterie their encounters are generally amicable. Female prairie dogs of breeding

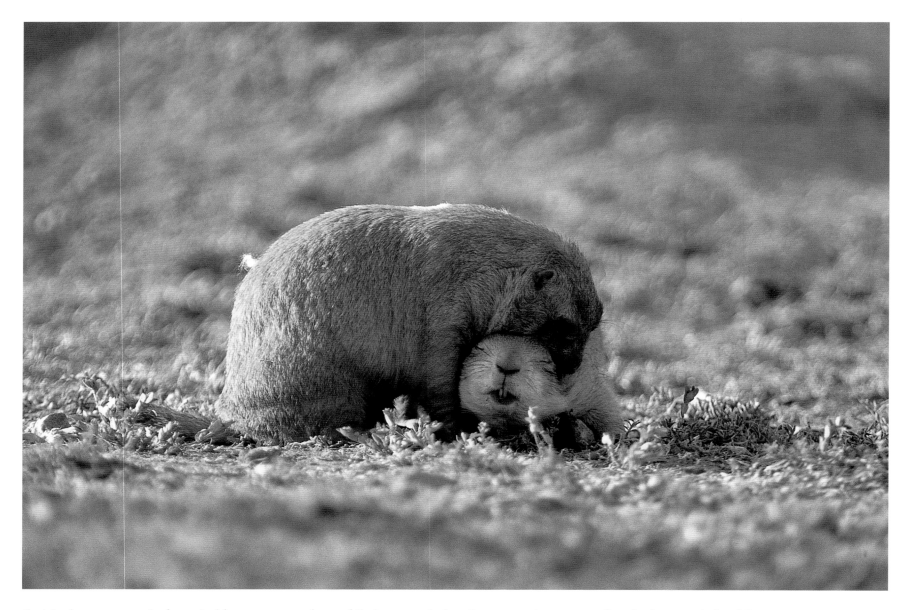

Prairie dogs are genuinely amicable among members of their own coterie, often grooming one another for long periods of time.

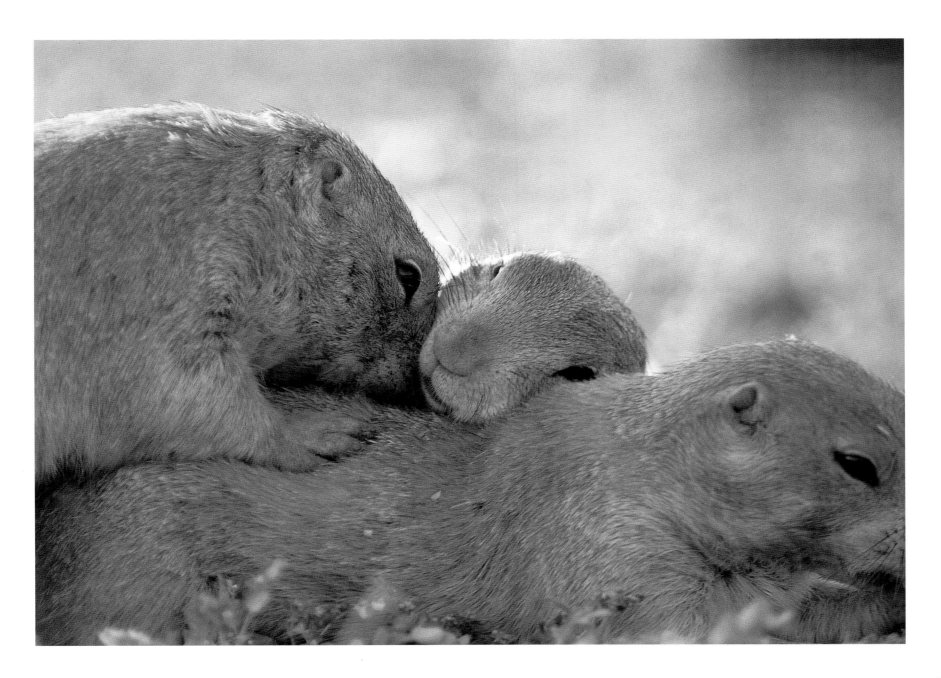

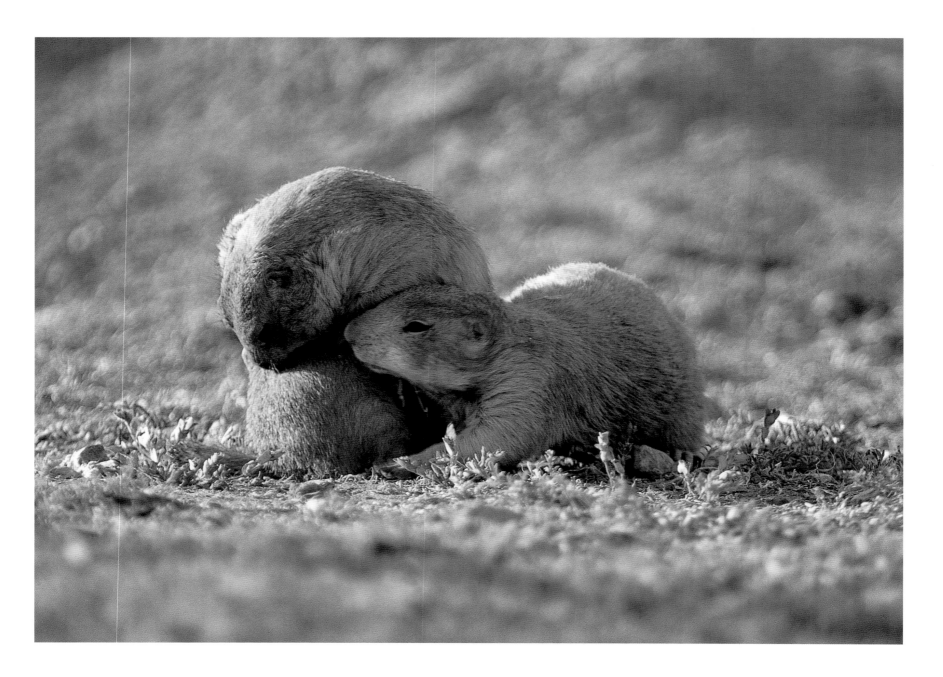

The Prairie Dog

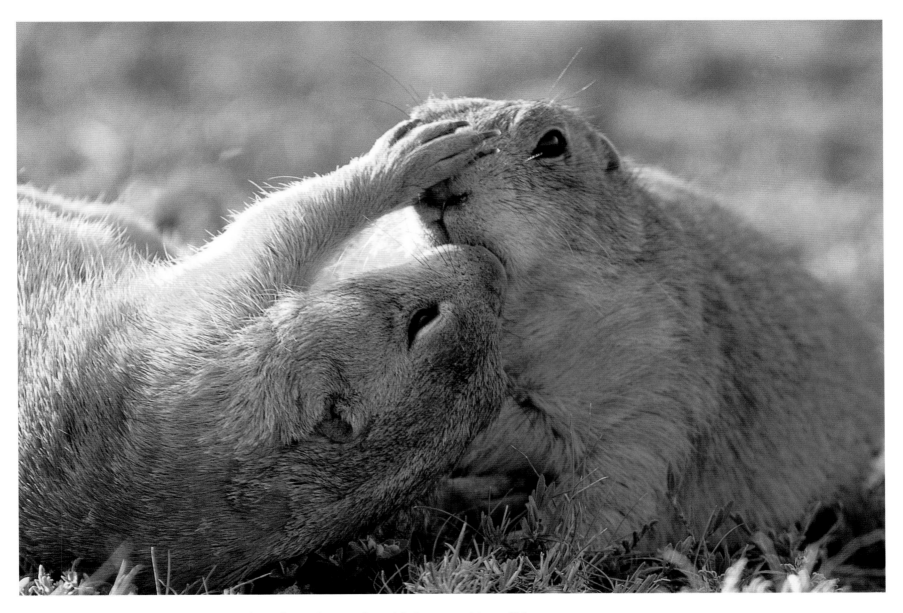

"Kissing" is a ritual that involves searching for oral scent that aids in recognition of kin.

age also show dominance over other females. As among males, the bigger females get to breed earlier, thus ensuring reproductive success. Studies have shown that dominance is associated with weight. The heavier the prairie dog, the more dominant it will be.

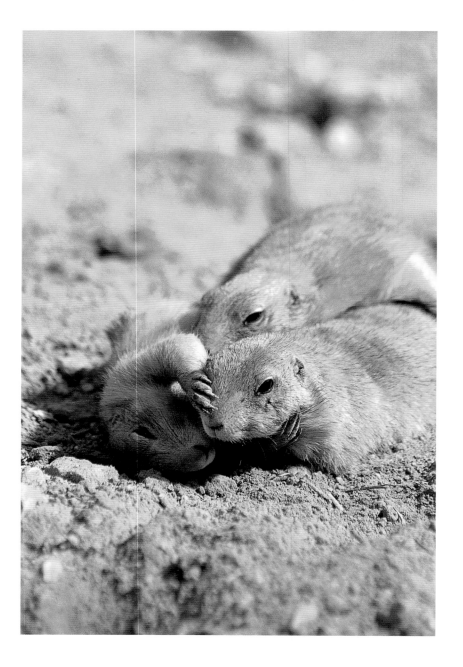

Inside the Coterie

A coterie is usually made up of a dominant male, three to four females in a harem, and half a dozen or so nonbreeding juveniles. Within the coterie, individuals are responsible for defending their home territory; building and maintaining burrows, which connect only within the coterie; raising young; and foraging for food and bedding materials.

Prairie dogs live in coteries for many reasons. First, living in groups aids in defense of the coterie. Second, it centralizes the foraging grounds so that individuals do not have to go far to find food. Good forage is essential to the reproductive success of a coterie, because, as mentioned earlier, body mass is directly attributable to dominance and, consequently, breeding order. Prairie dogs obtain 99 percent of their food from their own range, and since groups of animals such as coteries can defend more extensive foraging grounds, natural selection during the evolution of the species has preferred those individuals who are adapted to live communally.

To the untrained eye, coterie boundaries are usually undetectable. Each coterie's territory—with the exception of those on the periphery of a town—is contiguous with another family unit's claimed land. The continuous claiming of land makes use of all available forage within a territory and aids the entire town in the task of keeping vegetation cleared. Males often work the fringes of a coterie, defending it against neighboring prairie dogs, and females and juveniles often aid in the task. Because of the constant patrolling, it is rare to see intruders passing too far into the interior of another coterie's territory.

Coterie territories average approximately one acre in area, but their boundaries are dynamic. Rarely, coterie territories will split when relatives within a coterie band together and move to new grounds to start their own. Females, unlike males, generally do not migrate from their home coteries. Instead, they spend their entire life breeding and bearing young in the coterie in which they were born. As older females die, daughters take their place as the matriarchs of the coterie, and the family's bloodline continues. Reports have documented that a coterie can last many years with the same line of maternal offspring, although some last as little as one year. As time passes, however, coterie size varies. As juveniles mature and females remain to raise successive generations, males are forced out of the coterie by other, dominant males and venture out to form new coteries in adjacent areas. The constant cycle of coterie reproduction and domination causes the number of coteries to grow, and, consequently, the town grows and strengthens the colonial system on which the prairie dog and its ancestors have relied for eons.

Coterie boundaries are generally undetectable without close scrutiny.

Reproduction

As winter draws to a close, the urge to eat and then breed settles upon the coterie. Unlike some of its cousins in the squirrel family, the black-tailed prairie dog does not hibernate during the cold winter months. Instead, it relies on fat reserves built up through intense food gathering and eating in late summer and fall. Since the prairie dog is an opportunistic animal, it eats whatever it can find. In many cases the food may consist of roots or prickly pear pads instead of its staple diet of forbs and grasses.

The breeding season among black-tailed prairie dogs varies. In southern states, where warmer climates prevail, the breeding season may begin as early as late January. In the northern fringes of its range, the peak breeding period begins as late as March. Breeding season in a coterie creates a flurry of activity. Both males and females quarrel and spar with kin and strangers alike in order to assert dominance and gain the right to be the first to breed.

As among many other species of animals, breeding occurs only once a year for each female and is regulated by the receptiveness of the female. Estrus, or heat, is the period when an increase in the female hormone estrogen prepares the female genitalia for breeding. Perhaps most important, it is the time when the female ovulates and the single-celled eggs are released to await fertilization by the male's sperm in the uterus. The lengthening hours of daylight after the winter solstice trigger onset of estrus.

When a female is in estrus, courting males vocalize with a call that sounds much like the constant chirk of the antipredator call, but at a slower rate of repetition. Females, on the other hand, do not express the mating call as often as males do. Long-term observations of coteries have noted that females in heat only vocalize about 57 percent of the time. Courting males and females begin the process of nest building. Using grasses collected from the coterie, they begin building an underground nest in a nursery chamber, in which the female may whelp her pups. When mating time nears, the male begins to check the female for her readiness to breed by sniffing under her tail. This sniffing increases as mating approaches.

Breeding prairie dogs rarely mate aboveground. Instead, they retire underground to the safety of the burrow to mate. This adaptation not only increases the safety of the pair from predation, but also reduces competition from other males. After the female becomes pregnant, the young develop for thirty-four to thirty-five days. At the end of gestation they are born hairless and with their eyes closed. A newborn prairie dog, on average, weighs about a half an ounce and is about 2¾ inches long. Typically, three to five young of mixed sex are whelped, but litters of as many as eight young have been documented.

Newborn prairie dogs grow rapidly. In the first week of life their weight often increases by 40 percent. In two weeks they grow 2½ times larger. While increasing steadily in size, the young prairie dogs also grow hair during their time in the burrow. Their eyes do not open until the fifth week of life. When they are about six weeks old, they finally emerge from the burrow to explore the world outside.

While the young are still nursing, almost all feeding takes place underground. Aboveground, the juveniles are involved almost constantly in chasing each other and wrestling. Mothers often groom the young and sometimes engage in communal nursing. For the most part, prairie dog mothers are excellent at tending to the needs of their young, but there is also a sinister side to these creatures. The prairie dog is the only mammal known to commit regular infanticide on close kin's offspring.

Scientists have documented that infanticide within coteries is one of the major contributors to infant mortality among prairie dogs. On average, only half of the females raise litters to the age at which they emerge from the burrow. Predators, such as snakes, may account for some of these infant losses, but marauding lactating females cause the overwhelming majority of deaths in the same coterie as they attack and kill the pups of other females—in most cases, close kin. After a female has killed the young pups, she often eats them.

Problems of maternal nutrition are probably the primary reason for the infanticide and cannibalism. Lactating mothers need a higher degree of nutritional support for their bodies in order to successfully raise a full litter of young. It is also thought that the killings are a response to population density to help reduce future competition within the ranks of the coterie. Thinning the population of young prairie dogs makes more foraging areas and more food available to the rest of the group. Another interesting explanation for the marauding is that it reduces the chances of a marauder's litter being killed, since mothers of infanticide victims are less likely to kill another female's litter. In addition, females without pups help with the rearing of other pups in the coterie.

After leaving the burrow, the young prairie dogs continue to grow through the summer, fattening on grass so they can survive through their first winter. Predators invariably thin some of their number, but the ones that survive continue the age-old cycle of life, death, and rebirth in the prairie dog town.

Unlike some other burrowing rodents, black-tailed prairie dogs do not hibernate in winter.

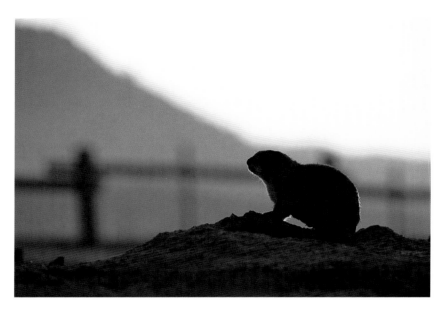

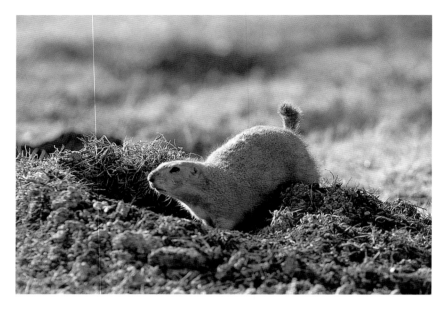

Onset of female estrus is regulated by a photoperiod response, initiated by an increase in daylight.

A prairie dog with a pile of dried nesting grass outside a burrow.

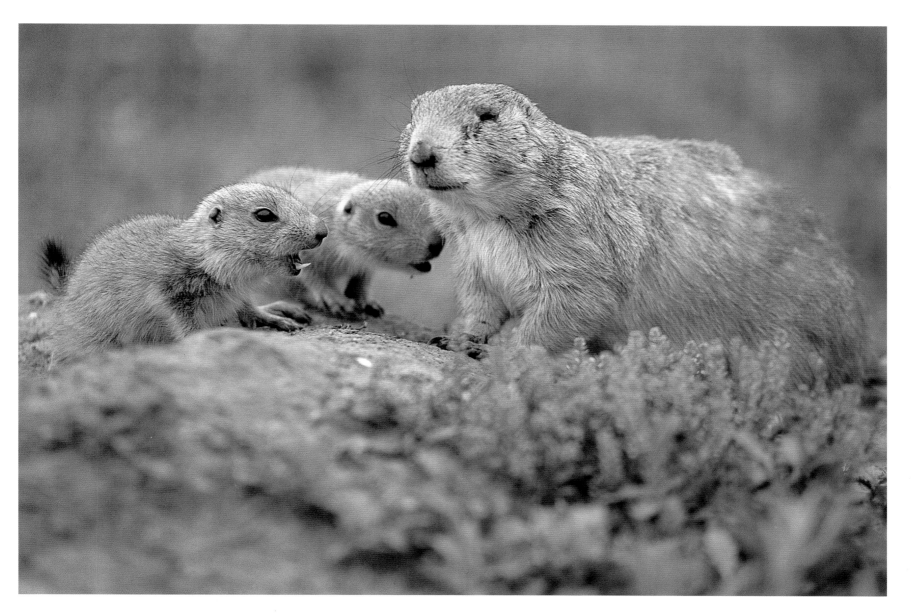

Females often suffer injuries while trying to protect their young from the attacks of other females in their coterie.

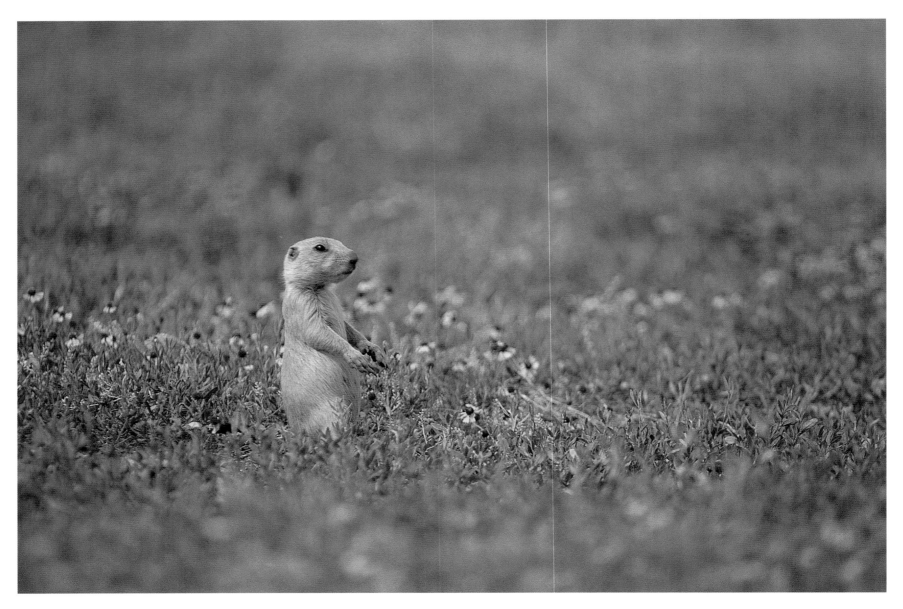

At six weeks of age, prairie dog pups emerge from the burrow.

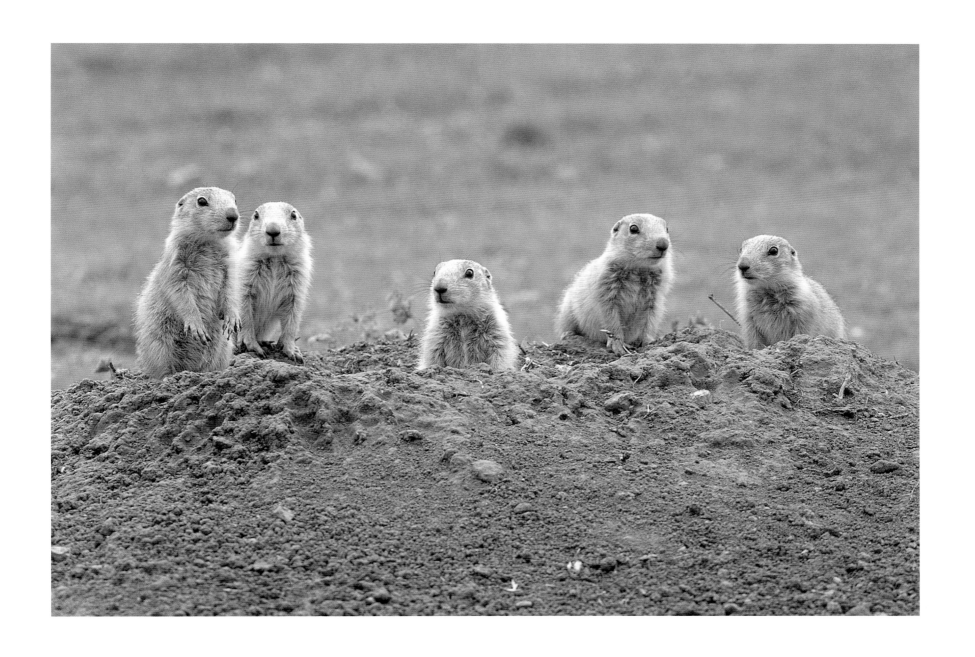

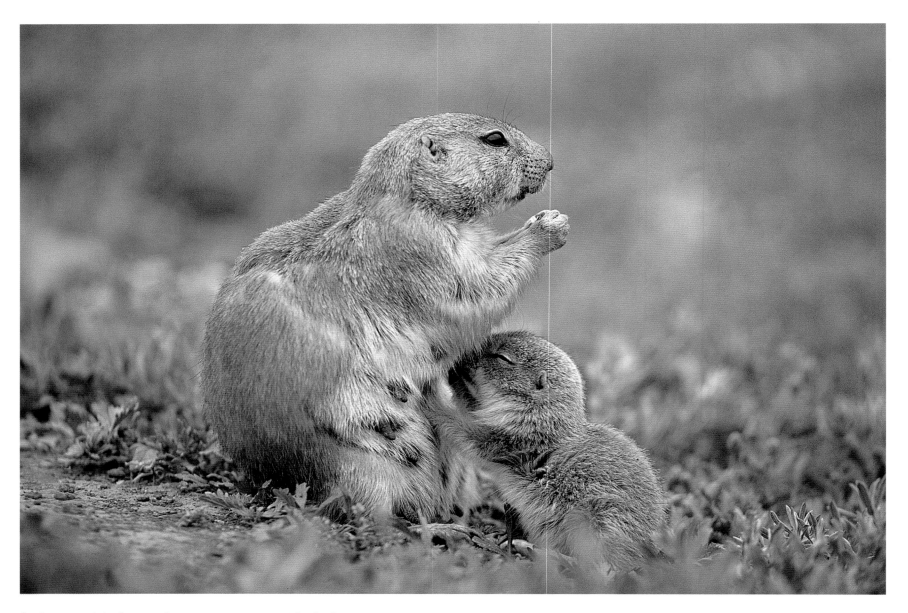

Seeing a prairie dog mother nurse a pup outside the burrow is rare.

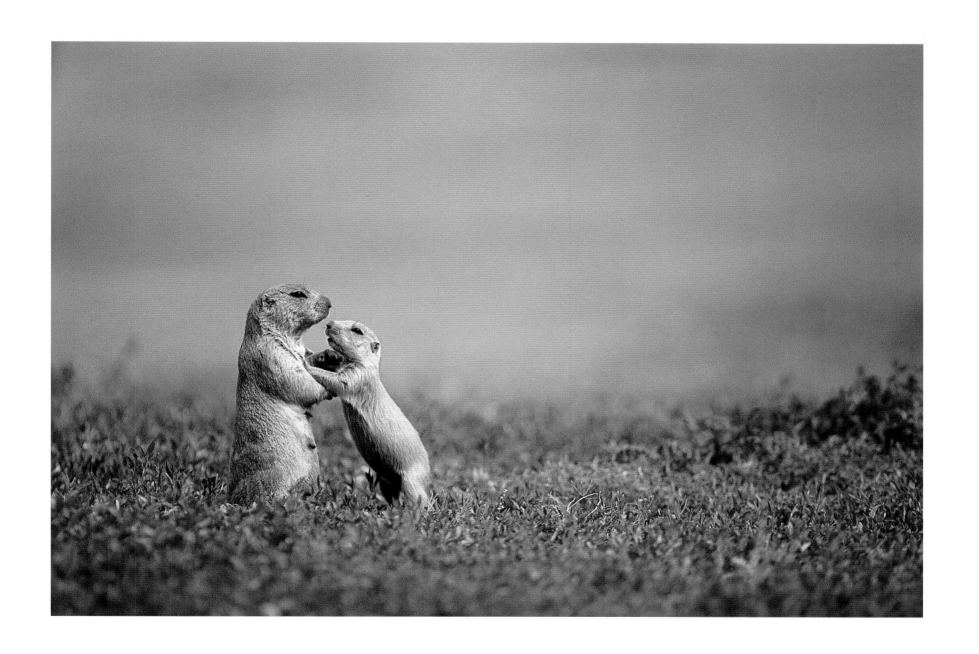

Juvenile prairie dogs often play by chasing and wrestling.

The Prairie Dog

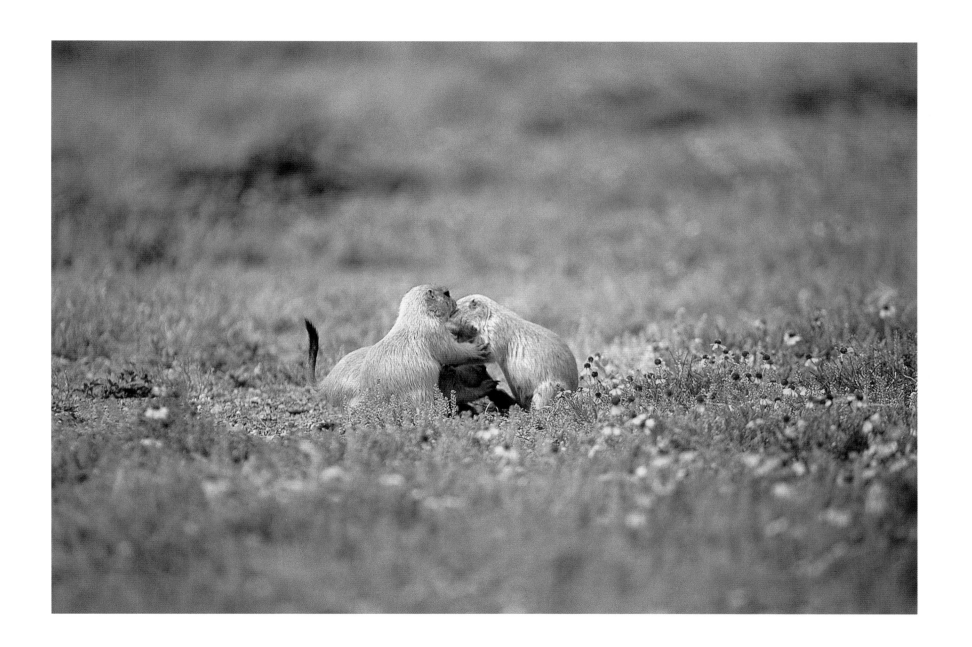

Allies and Enemies: The Prairie Dog and its Ecosystem

One quick visit to a prairie dog town may be misleading. One of the most common casual observations about a town is its lack of vegetation. To the uninitiated, a prairie dog town seems like a wasteland devoid of all life except the prairie dogs themselves. Nothing could be further from the truth. Spend enough time in a prairie dog town, and you will see that it is teeming with life. All sorts of animals besides the prairie dogs find refuge and food within the town. In ecological terms, the prairie dog is referred to as a keystone species, which means that it is a crucial link, creating and maintaining a habitat that supports many other species besides itself. The concern among scientists is that if the remaining 2 percent of all prairie dog–habitable acreage is allowed to dwindle any further, an entire ecosystem—one that is unique to the Great Plains of the United States—will be

destroyed and lost forever. Records show that forty species of mammals, ten species of amphibians, ninety species of birds, fifteen species of reptiles, twenty-nine species of insects, and approximately eighty species of plants are associated with black-tailed prairie dog towns.

Each of these animals has a different relationship with the prairie dog. Some prey on the rodent, using it for food, while others simply reap the benefits of the prairie dogs' colonial habit. Some animals live in abandoned prairie dog burrows, and some are simply attracted to the open spaces the prairie dog creates. Of the forty species of mammals that the prairie dog benefits, many are mainstays of the plains and icons of the Old West. Some, like the bison and the pronghorn antelope, live communally with the prairie dogs. The little diggers' activities actually improve forage for grazing ungulates. A few species rely solely on the prairie dog as a means of survival. This fact is what worries some in the scientific community. The fear is that when the prairie dog goes, so will many other species.

Prairie Dogs and Other Mammals

For tens of thousands of years on the plains of North America, many forces of nature worked to sustain the grasslands. Of those forces, fire was perhaps the most important in the health of the prairie. Before the West was settled, grass fires were a natural part of the prairie ecosystem, coming at three- to five-year intervals. Fire helped burn back old-growth plants. On the plains, fire helped remove the dead grasses and allowed new plants to emerge from the charred soil. Often, if an area goes for an extended time without the benefit of fire or some other disturbance, it becomes a monoculture, in which only one type of plant grows. Burning, in effect, helped biodiversity by allowing a variety of plants to take the place of a single species. Fire also set back climax vegetation. On the High Plains of Texas today, many areas that were once vast shortgrass prairies are choked with mesquite trees. As easterners settled the plains, they suppressed natural fire cycles, and climax vegetation, such as the trees, was allowed to take over. Succession such as this can be detrimental to open- area species such as the pronghorn antelope and the prairie dog, both of which rely on their sight as their primary defense.

When fire was a dominant force on the plains, bison were the foremost grazer. The bison ecosystem, well documented in many publications, was based on the diverse grass

species that thrived on the plains. The bison benefited the prairie dog by overgrazing some areas of their range. Prairie dogs found such close-cropped ground more acceptable for habitation and would quickly move into such areas that were adjacent to their existing colonies. At Wind Cave National Park in South Dakota, research has shown that the bison herd feeds, on average, 56 percent of the time at the edges of the prairie dog towns there. The bison's diet at the edges of these towns consists of 94 percent grass and approximately 6 percent forbs and shrubs. These numbers, and researchers' observations, indicate that bison prefer to feed near prairie dog towns, possibly because of the increased diversity in plant species there.

Once, while on a photographic foray at a prairie dog town at the Wichita Mountains National Wildlife Refuge near Lawton, Oklahoma, I was lucky enough to witness a number of bison, perhaps thirty, interact with a small prairie dog town. When the sun rose, the bison were feeding about a quarter of a mile from the town, but as daylight spilled across the landscape, they slowly began to approach the edge of the town.

The bison and the prairie dog lived communally
on the plains for thousands of years.

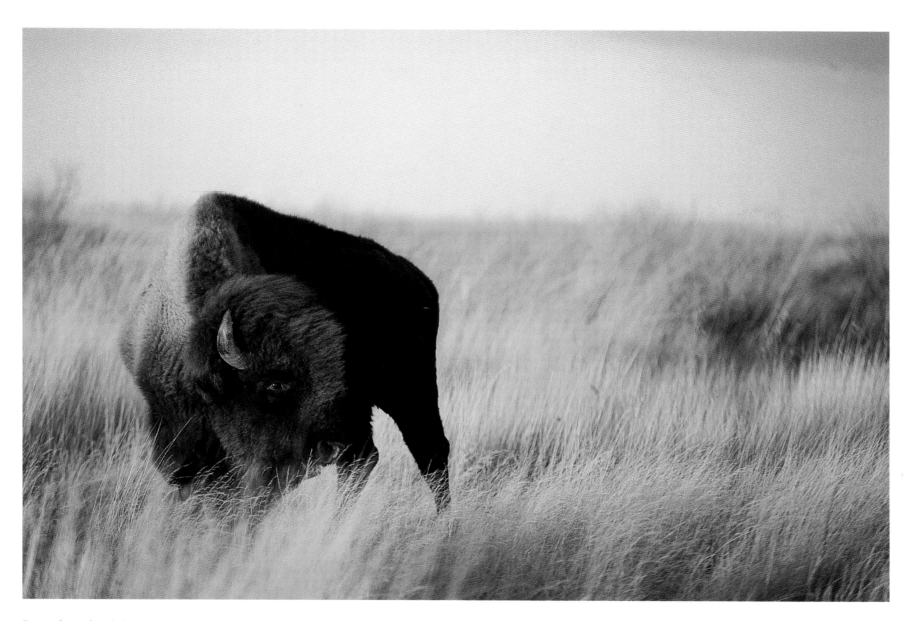

Bison benefited the prairie dog by overgrazing some areas of their range.

Bison often find the loose soil of a prairie dog mound an inviting place to take a dust bath.

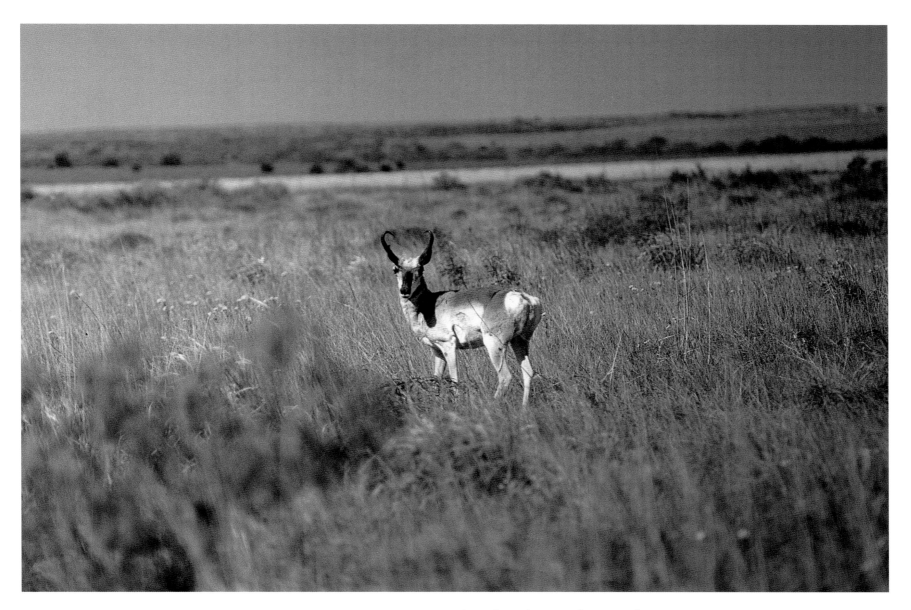

The burrowing of prairie dogs actually improves forage for grazing animals such as the pronghorn antelope.

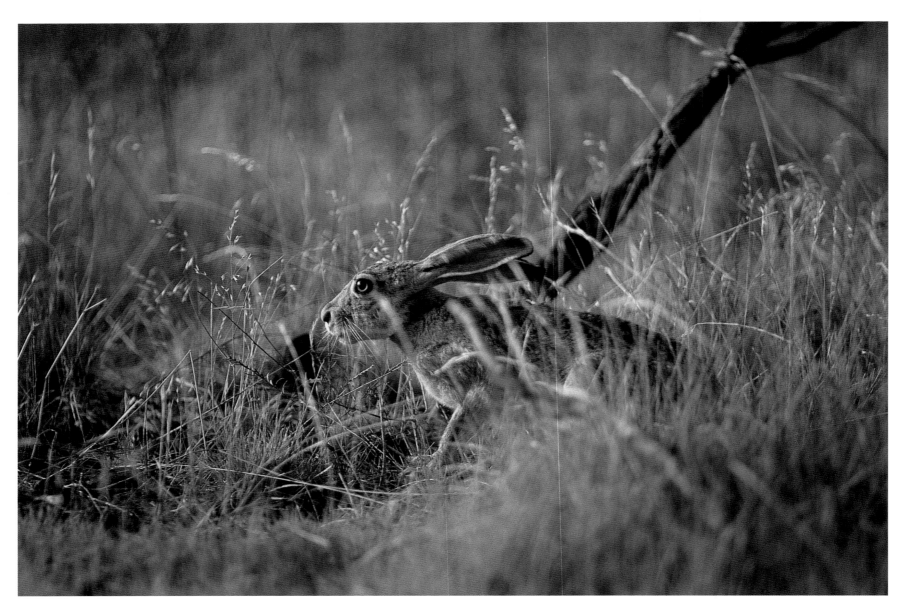

The black-tailed jackrabbit shares the habitat of the prairie dog.

Cotton-tailed rabbits often live in abandoned prairie dog burrows.

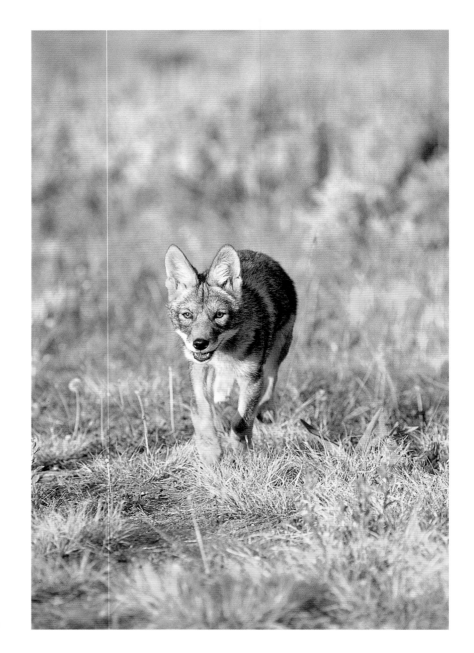

Coyotes are major predators of prairie dogs.

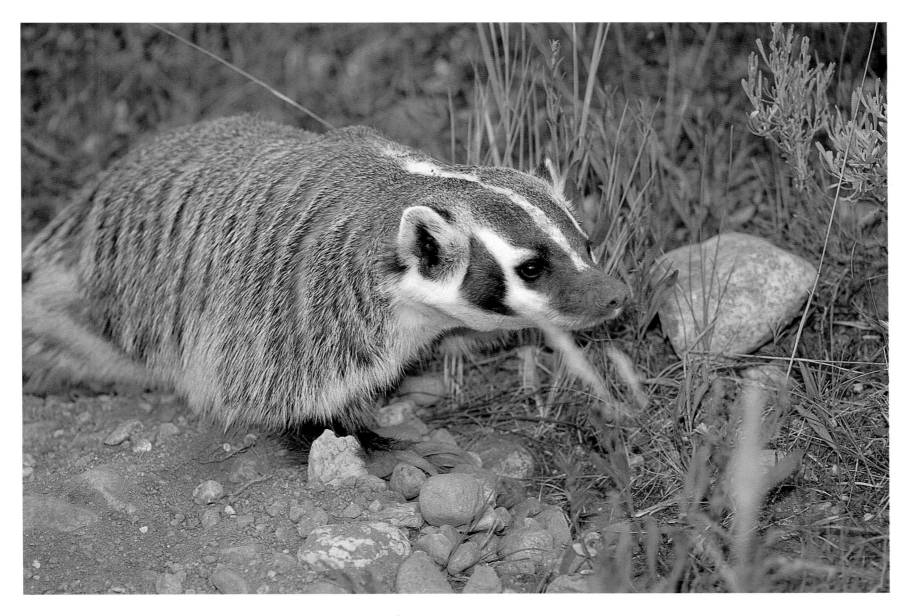

Badgers are among the deadliest of all predators of the prairie dog.

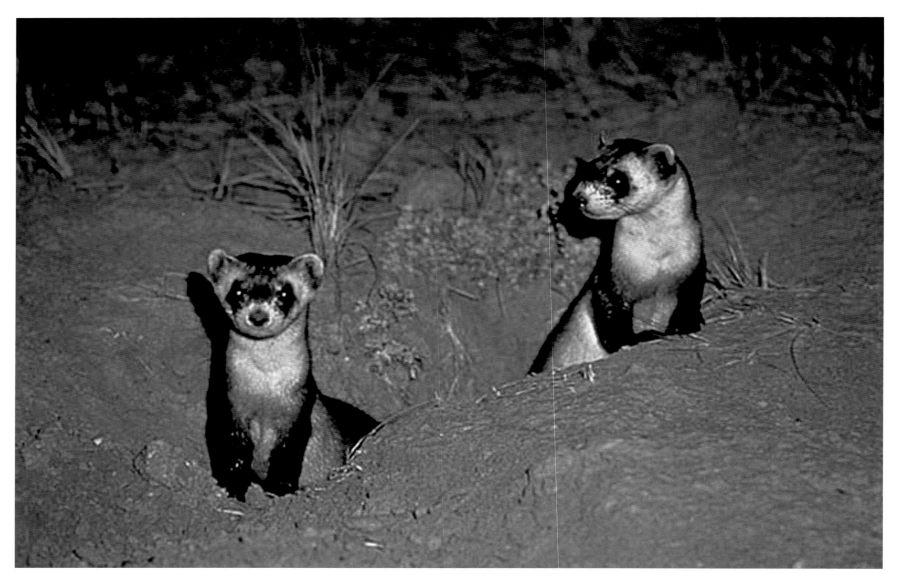

The black-footed ferret, a highly endangered species, may prove to be the prairie dog's savior, since protection for the ferret means protection for the prairie dog. (Photo by Luray Parker/U.S. Fish and Wildlife Service)

Without hesitating, they continued feeding their way closer to the dogs, grunting and moaning every step of the way. It was not long until the bison were in the middle of the town. Prairie dogs were either running around looking for cover or barking angrily at the intruders.

One bison, a big bull—and by the way the other bison treated him, the patriarch of the herd—put his head down to a burrow just as a dog ducked inside for cover. He sniffed around the burrow opening for a few seconds, dust flying up around his head with each deep exhale that he released from his nostrils. Without warning, he placed his enormous head on top of the burrow mound and began to rub his thick hair into the dirt. After a few seconds the bull knelt down on his front knees and continued to rub—although now with more enthusiasm. Then he began to roll on his back in the dust. Once he was satisfied with his dust bath—an ancient adaptation that the bison has developed in order to help rid itself of insects— he got up and began to graze again. Curiously, a cow and a subordinate bull followed suit and rolled in the same place the old bull did. I do not know why the bison selected that particular site on which to roll, but I suspect it had something to do with the availability of loose dirt and some unknown smell that attracted their attention.

Similarly, pronghorn antelopes benefit from their mutual relationship with the black-tailed prairie dog. In the same study at Wind Cave National Park, the researchers discovered that pronghorns use the middle part of the prairie dog town, whereas bison concentrate on the periphery. In the 905 feeding times that were recorded, pronghorn antelopes fed 461 times at the town's center compared to 185 times at the town's edge and 259 times at uncolonized areas of the park. Therefore, the antelopes chose to dine at the town's center 51 percent of the time, eating mainly forbs and shrub species.

Although prairie dogs benefit grazing mammals on the plains, other mammals look to the prairie dog town as a source of shelter or food. Rabbits—both cottontail and black-tailed jackrabbits—use abandoned burrows as shelter and brooding areas. Many predators look to get a meal at the expense of the rodents; coyotes, the High Plains drifters, find the prairie dog acceptable fare. Coyotes and other predators, such as foxes, are adept at catching prairie dogs when the rodents are feeding away from their burrows.

Among the deadliest of all predators of the prairie dog is the badger. A short, stocky mammal, the badger is known for its grizzled black hair, strong jaws, sharp claws, and ferocious disposition. A shy animal, the badger is rarely seen, as it is almost exclusively nocturnal. It can wreak havoc on a prairie dog town, however. Like the prairie dog, the badger is a burrowing animal that can dig a hole in a matter of seconds. Because of this ability, it can dig into prairie dog holes and drag the rodents out of their dens without having to wait for the prairie dogs to emerge.

One of the rarest of all mammalian predators may turn out to be the prairie dog's salvation. The black-footed ferret is now the focus of intense investigation by researchers on the plains. The ferret owes its entire existence to the prairie dog, making its home within prairie dog towns and feeding exclusively on prairie dogs. Although black-footed ferrets were thought at several times during this century to be extinct, a small population was discovered in 1981 near Meeteetse, Wyoming. Some current estimates place the number of black-footed ferrets in the wild at as few as fifteen. Because of this dismally low number, many concerned individuals are working hard to restore the black-footed ferret to its native range, but to do that they must first save the prairie dog's remaining habitat.

Since the black-footed ferret was rediscovered in 1981, scientists have initiated captive breeding programs in an attempt to increase the number of ferrets and reintroduce them to their native habitat. They use the ferrets' more common cousin, the Siberian polecat, to learn the effects of releasing animals raised in captivity back into the prairie dog ecosystem. The relative success or failure of the polecats' captive breeding program is a model for breeding and releasing black-footed ferrets back into the wild. Polecats are similar to the black-footed ferret, yet they are more plentiful, so if some die in the wild during the experiment it is not as catastrophic as it would be if even a few ferrets were to die. The polecats are sterilized so that they do not breed and populate the prairie dog range.

Aside from the black-footed ferret, the swift fox is another animal in trouble as a result of prairie dog eradication. The swift fox, although not as rare and dependent on the prairie dog as the black-footed ferret, is also dwindling in numbers because of the reduction in prairie dog habitat.

Prairie Dogs and Avian Diversity

More than twice as many species of birds as of mammals are attracted to the prairie dog towns. Many of the birds, such as meadowlarks and starlings, like the open spaces of the towns, which afford easier foraging for seeds and an increased number of insects. Some birds even live in harmony with the prairie dogs.

The burrowing owl, a diminutive predatory bird that stands only eight to ten inches high, has a unique relationship with the prairie dog because it lives among prairie dogs yet does not feed on them. Perhaps just as visible as the prairie dog, the burrowing owl can be seen at burrow mounds that have been abandoned by prairie dogs. Early summer will find juvenile owls, not yet able to fly, hanging out like a bunch of teenagers on a street corner, watching all of the action from their burrowside vantage point. The owls, despite their name, do not dig burrows themselves, but live in prairie dogs' abandoned burrows. A pair of adult owls, searching for a place in which to raise their young, will choose a burrow and make a nest out of dried grass, feathers, and dried manure from cattle or other mammals. Before the young can fly, they leave their burrow, but they stay within a close distance of the shelter. Adult owls, with their large, haunting eyes, are voracious hunters, preying on a variety of insects, small rodents (mice and rats), reptiles, and amphibians. Because they are almost strictly diurnal, these owls can be seen often in an active town.

Many other avian species prey on prairie dogs. Golden eagles and ferruginous hawks are especially deadly. The ferruginous hawk has seen a decline in its numbers over the past several years because of its reliance on the declining prairie dog population for food. The mountain plover, because it relies on the open grasslands of prairie dog towns for nesting grounds, has also experienced a severe reduction in its numbers to the point that it has been listed as an endangered species.

Crows find insects and other food in the clipped grass of the village.

Western meadowlarks live throughout the High Plains near prairie dog towns.

The roadrunner is one of the many bird species found in the prairie dog habitat.

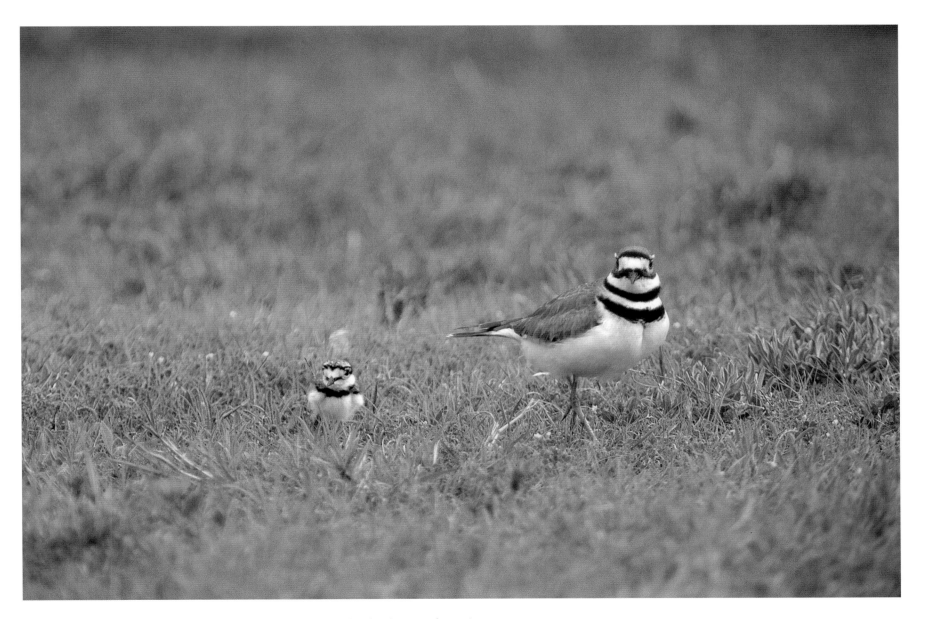

Killdeer prefer the open areas created by prairie dogs for feeding and nesting.

Burrowing owls inhabit prairie dog burrows and raise their young in them.

The Prairie Dog

Prairie dogs and burrowing owls have no fear of each other.

A falcon swooping on prey.

The Prairie Dog

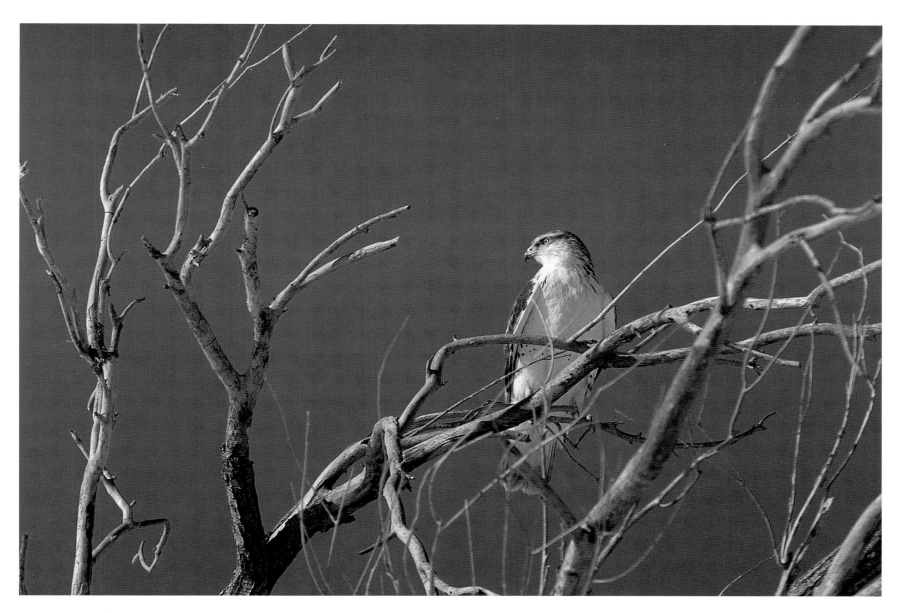

Hawks, such as this red-tailed hawk, are common predators of prairie dogs.

Harvester ants often build their nests in the cleared
ground of prairie dog villages.

Other Friends and Enemies

Numerous other species also depend upon the ecosystem the prairie dog creates for sustenance and survival. A host of invertebrates make themselves at home in the dark confines of prairie dog tunnels. Black widow spiders sometimes build their webs just below the surface of the burrow crater in order to trap insects that fall into the hole. Mole crickets, subterranean cousins to the common crickets found on the front porches of many homes, also use the cool, damp burrows.

Many snakes traverse the prairie dog town. Most, like the rat snake, have a benign relationship with their hosts. Most simply slither through a town looking for an empty burrow into which to crawl. The western diamondback rattlesnake, however, has more sinister notions as it creeps stealthily into a town. Although the diamondback does not affect adult populations a great deal, it can take out a den of immature dogs in no time. Being an "eat first, digest later" species, the rattlesnake can quickly swallow a small prairie dog and slither away. When a rattlesnake is seen in a coterie, the adults will

Many species of animals, including the threatened Texas horned lizard, can be found in a prairie dog town.

The kingsnake also shares the plains with the prairie dog.

A western diamondback rattlesnake in the entrance
to a prairie dog burrow.

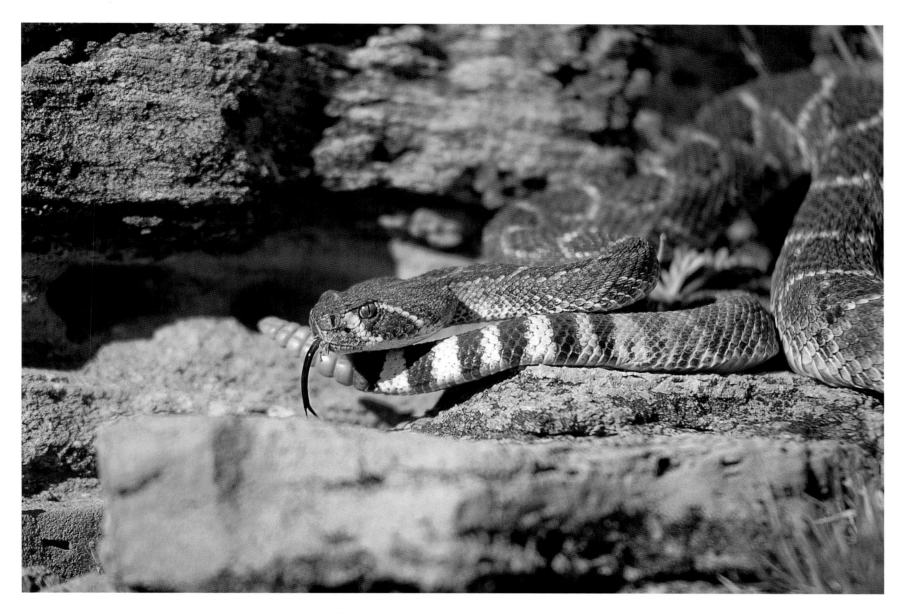

The western diamondback rattlesnake is a predator of prairie dog pups.

often come to the rescue quickly. Many old-time accounts speak of the use by prairie dogs of the mongooselike tactics of attacking a rattlesnake singlehandedly, from behind. Actually, though, most of the time the dogs will not attack directly. Instead, they will circle the snake, taking turns nipping and barking at the reptile. Shaken, the rattlesnake will try to fight back, but soon more adults come to battle the intruder. After it is dead, the prairie dogs will drag the snake into an abandoned den and quickly bury it under a pile of dirt.

The prairie dog plays a vital part in creating and maintaining a vast plains ecosystem. Without the prairie dog, many species could give way to extinction, or perhaps, at the very least, extirpation from an area.

The Prairie Dog Wars

On July 31, 1998, the National Wildlife Federation (NWF), in a news conference in Denver, Colorado, announced that it had petitioned the U.S. Fish and Wildlife Service (USFWS) to list the prairie dog as a threatened species under the Endangered Species Act.[4] The introduction to the petition reads as follows:

> While the Endangered Species Act (ESA) is often thought of as only protecting listed species, a central and express purpose of the ESA is to "provide a means whereby the ecosystems upon which endangered species and threatened species depend may be conserved . . ." 16 U.S.C. § 1531(b). Although black-tailed prairie dogs are an important species in their own right, both the species itself and the habitat that it creates, are vitally significant for numerous other prairie species. By

listing black-tailed prairie dogs, USF&WS will not only be taking a legally mandated step to conserve a threatened species, it will also be fulfilling the highest purposes of the ESA by protecting a key component of natural short-grass prairie ecosystems.

A news release distributed by the NWF contended that "along with reversing the decline of the prairie dog itself, the petition aims at harnessing the power of the Endangered Species Act (ESA) to restore functioning Western short grass prairie habitats, on which the prairie dog and scores of other species depend. . . . An ESA listing of the black-tailed prairie dog would put an immediate stop to both unregulated shooting and poisoning." With that announcement, the NWF admits, it may have started one of the most controversial endangered species issues of the decade and, as some have indicated, perhaps even the century.

At the same time it introduced the petition, the NWF asked that the prairie dog be added to the "threatened" list immediately. NWF officials claimed that the emergency listing would eliminate the "shoot, shovel, and shut up" damage that could occur should the proposition be left to debate for any length of time. The NWF's biggest concern was that some landowners would kill every prairie dog on their land before the animals were listed as threatened, thus avoiding the later trouble of getting a permit to control the prairie dogs.

The release of the petition started a whirlwind of activity. Conservation groups, landowner rights coalitions, and state wildlife agencies all jockeyed for their respective positions on the issue and formulated statements on their stances. At the same time, news media were hot on the story. Once the petition was filed, the USFWS had ninety days in which to respond to the request. When the USFWS released its decision, many on the prairie dog's side were disappointed.

The petition brings full circle a war on prairie dogs that was started a century ago when C. H. Merriam, director of the U.S. Biological Survey (the precursor of the U.S. Fish and Wildlife Service), erroneously reported that 256 prairie dogs consume as much grass as a 1,000-pound steer and that the rodents contribute to a 75 percent decline in rangeland productivity. Since then, individual states and the federal government have waged war against the sentinel of the plains, with devastating consequences for the little animal.

A Historical Perspective

Merriam made his erroneous claims in the U.S. Department of Agriculture's *Yearbook of Agriculture* in 1901. In that same report, he estimated that prairie dogs inhabited approximately 63 million acres in the United States—indeed, a staggering number. Four years later, Vernon Bailey, chief naturalist for the Biological Survey, wrote a report on his survey of the prairie dog's range. In Texas he had made a remarkable discovery. In his *Biological Survey of Texas* (1905) he described a prairie dog town that stretched from San Angelo, a town along the Concho River in southwestern Texas, north to Clarendon, located in the Texas Panhandle sixty miles southeast of Amarillo. In all, the prairie dog town was an estimated 250 miles long and a hundred miles wide. To put that number in perspective, the town covered an area of twenty-five thousand square miles—sixteen million acres. Bailey estimated that this single town had four hundred million inhabitants and that there were eight hundred million prairie dogs in the state of Texas.

The results of Merriam's and Bailey's reports were a scathing, albeit untrue, account of the prairie dog and its effect on the plains. They estimated, at the time, that the black-tailed prairie dog reduced the productivity of rangelands by 50 to 75 percent—a number that is still quoted today by anti–prairie dog factions and vehemently denied by pro–prairie dog conservationists.

In fairness to Merriam and Bailey, anti–prairie dog sentiment and the overall fear that the animal would ruin rangelands existed before their reports. An interview with Texas Panhandle pioneer B. A. Owen conducted in the 1930s by the Panhandle Plains Historical Museum in Canyon, Texas, revealed that very early on in the settlement of the plains there was an interest in controlling the staggering numbers of prairie dogs. Owen spoke of a time on the NUN Ranch, in what is now Swisher County, Texas, when the owner of the ranch, a Mr. Godair, directed Owen to find out the best way to eradicate a prairie dog town that covered an estimated 150 square miles of land. Owen wrote:

I ordered one hundred pounds of strychnine and four hundred pounds of cyanide of potash through Doss Bros. of Colorado City [Texas]. Of course we couldn't get all of it at one time, but we got it as we needed it. I also ordered five hundred bushels ow [sic] of wheat to start with. In experimenting with different formulas I found that 2 oz of strychnine and 4 oz of cyanide gave the best results. We got started about Dec. 1st and worked fifteen men all that winter and had signal success. The next year (1899) we had a good

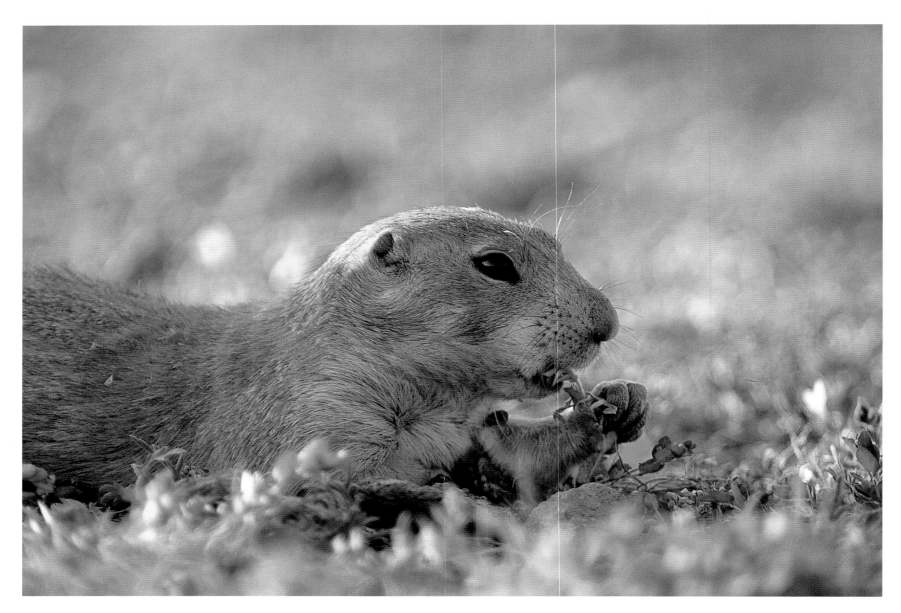

Since the early 1900s, prairie dog population and habitat have been reduced by 98 percent.

season and the grass was knee high all over the ranch. Mr. Godair came to the ranch the next fall and asked me what I had to spend on the dogs. I told him approximately six thousand dollars and he said he wouldn't have them back for twenty thousand dollars.

Although Owen conducted the prairie dog experiment four years before Merriam's report and seven years before Bailey's, public sentiment in the agriculture industry and the halls of local, state, and federal governments had already started to turn against the prairie dog. A study some twenty years later, conducted by government researchers W. P. Taylor and J. V. G. Loftfield, helped fuel the fire of anti–prairie dog attitudes when they released a government document that stated that the prairie dog was "one of the most injurious rodents of the Southwest and plains regions . . . [and its range is devoid of] vegetation in its entirety from the vicinity of its home." With that, the prairie dog's fate on the plains was sealed. In the time between the Merriam and the Taylor-Loftfield reports, prairie dog acreage decreased by 25 percent.

Arming themselves with such misleading ecological statistics, farmers, ranchers, and government agencies in the early days of the twentieth century went to war against not only prairie dogs, but also all other animals that threatened the livelihood of agriculturists. Animals such as the wolf, coyote, mountain lion, and bobcat, which were subject to bounties, as well as the jackrabbit and pocket gopher were poisoned until their numbers became disturbingly low. The poison, either strychnine or cyanide, was extremely effective. In 1922, government agents poisoned one million acres of prairie dog habitat in the Texas Panhandle, killing off 90 percent of the dogs.

In her 1971 book *Must They Die?* Faith McNulty paints an ominous picture of the government animal control policies set in place in the twenties and the attitudes that still prevail today. "Tangible value is all that matters," she writes, "and the accompanying belief that anything that costs anyone money— a coyote that eats a sheep, for instance, or a prairie dog that takes up space on the range—must be destroyed. Conservationists, who beg for recognition of the intangible value— scientific, ecological, and aesthetic—of wild fauna, are continually coming up against practices and ideas evolved solely from the economies of the past."

During the 1930s, as America waded through the dregs of the Depression, the war on the prairie dog intensified. Aided by the Civilian Conservation Corps and the Works Progress Administration (programs initiated by President Franklin Roosevelt), the Bureau of Biological Survey (BBS), a division of the U.S. Department of Agriculture, stepped up the war on the rodents, and their widespread eradication was

commonplace. In 1935, the U.S. Bureau of Biological Survey reported that "the last extensive dog town in the Plains Area [Texas] passed out of the picture."

In the 1940s the BBS administration was transferred to the Department of the Interior. During the decade, spending on control programs, including predators, jumped from $2,714,023 to $4,629,053, largely because a new compound was introduced to control rodents. Sodium fluoroacetate, the chemical commonly known as 1080, was extremely deadly for the animals that the bureau had targeted for control. A salt that looks like powdered sugar, 1080 affects the nervous system of its victims. First, the animal goes through convulsions, followed by vomiting and then death. So deadly was 1080 that Eric Peacock, a bureau biologist, wrote that it has "the potential of a biological high explosive."

In the decade of the 1960s, the Bureau of Land Management is reported to have placed on federal land over 6,400,000 poisoned baits to eradicate rodents and larger animals such as coyotes.

Consider the numbers: Historically, black-tailed prairie dogs numbered an estimated five billion animals throughout their range, which extended from the Trans-Pecos region in far west Texas north through the plains states of New Mexico, Colorado, Kansas, Wyoming, Nebraska, South Dakota, North Dakota, and Montana. Today, the USFWS estimates their number to be roughly ten to twelve million individuals nationwide. Since the time of the Taylor-Loftfield report, it is estimated, the prairie dog population and its habitat have been reduced by 98 percent. The NWF states that in regard to the current status of the prairie dog, "about 72 percent of the occupied U.S. habitat, and all the remaining large complexes of black-tailed prairie dog towns, occur in three states: Montana, South Dakota and Wyoming. Half of this occupied habitat is in South Dakota where four large complexes still exist, three of them on tribal land. Approximately three-quarters of the black-tailed prairie dogs in South Dakota are located on seven Sioux Indian Reservations. As a total, South Dakota has 244,520 acres of prairie dog towns."

Table 1 shows the historic numbers for the prairie dog states, based on the 1998 estimates reported by the NWF in their petition. From an ecological standpoint, the change in acreage for each state is sobering.

Judging by the numbers, it would seem that the prairie dog is doomed to extinction. Everywhere the prairie dog lives, its numbers are faltering. The reason this decline is allowed to continue, and even encouraged, appears to be a combination of lack of information, public policy, and old-fashioned peer pressure. The overriding sentiment seems to be, "Grandpa killed prairie dogs, and so did Dad, so I guess I will too." Although the future may look bleak for the black-tailed prairie

dog, however, some attitudes and policies are improving. Conservation efforts for the prairie dog have begun to spring up across the plains.

Table 1. U.S. prairie dog acreage, 1870 and 1998.

State	Acreage 1870	Acreage 1998	Decline (%)
Arizona	650,000	0	100.0
Colorado	7,000,000	44,000	99.4
Kansas	2,500,000	36,000	98.6
Montana	6,000,000	65,000	98.9
Nebraska	6,000,000	60,000	99.0
New Mexico	12,000,000	15,000	99.9
North Dakota	2,000,000	15,000	99.3
Oklahoma	950,000	8,500	99.1
South Dakota	1,757,000	244,500	86.0
Texas	56,833,000	22,500	99.9
Wyoming	16,000,000	125,000	99.2
Total for United States	116,000,000	635,500	99.5

(Source: National Wildlife Federation)

Words and Actions

Since the 1970s, government-sponsored poisoning programs have decreased significantly, yet they still occur. In fact, usable prairie dog habitat continues to decrease at an alarming rate. Some estimates claim the amount of prairie dog habitat declined an average of 60 percent from 1988 to 1998. The total land inhabited by prairie dogs fell from 1.3 million acres to approximately 635,500 acres during those ten years. Some people concerned about the prairie dog and its environment believe that if the trend continues unchecked, the prairie dog could be extirpated from its native habitat within this century. On the other hand, private landowners are afraid that if the prairie dogs are listed as endangered, they will have to sacrifice economic gains in order to accommodate the protection of the prairie dog and its ecosystem. The controversy strikes at the heart of the private property rights issue.

"Education is the key in saving the prairie dog," Kevin Mote, endangered resource specialist for the Texas Parks and Wildlife Department, once told me as we were kneeling in the middle of a prairie dog town in the Texas Panhandle, checking on a nest of burrowing owls. "Unless people start to understand the role of the prairie dogs in the ecosystem, they [prairie dogs] are surely doomed." Mote, who has spent a considerable amount of his professional life studying the prairie dog

In the ever-developing plains states, prairie dogs and humans often clash as their habitats overlap.

and the complex ecosystem it creates, believes it is not too late for the Great Plains digger. Many who are interested in the conservation of prairie dogs share his sentiments. An article in the March 1998 issue of *Smithsonian* magazine illustrates vividly the sense of commitment some show toward the prairie dog: "Yet even as prairie dogs gain more enemies, they are finding new friends," writes Catherine Dold. "Animal lovers like Martin [a volunteer from Hutchinson, Kansas who was involved in a prairie dog relocation effort in an area in the town that was to be developed into a municipal baseball field] are taking up the cause, and biologists are warning that prairie dogs are actually good for the environment, even vital to a healthy prairie ecosystem. Some say that these animals are so important, and in such trouble, that just like gray wolves and manatees, they should be protected as endangered species." Dold points out that although eradication programs are not as common as they once were, they do continue with some frequency on suburban and public lands. The debate over the prairie dog rages on, however.

As a symbol of the plains, much like the bison or the pronghorn antelope, the image of the prairie dog is beginning to make a turnaround. Indeed, in a true bit of irony, the burrowing rodent has been thrust into the unlikely position of being an icon for life on the plains at the beginning of the twenty-first century. High on the Llano Estacado, one hundred miles north of where the High Plains abruptly begin as they jut north

The Prairie Dog Wars III

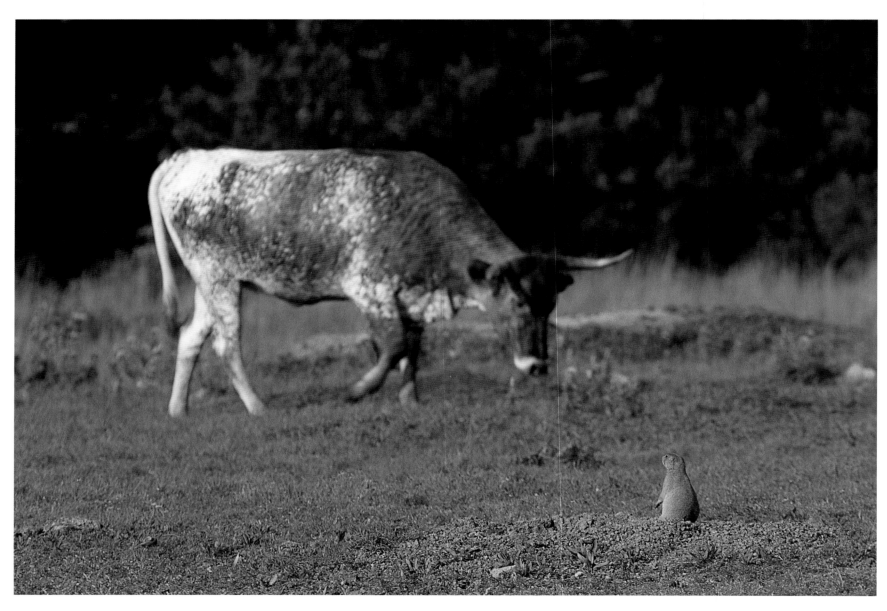

Like bison, cattle can often benefit from the prairie dog's disturbance of the soil.

Prairie dogs in public places often learn not to fear humans.

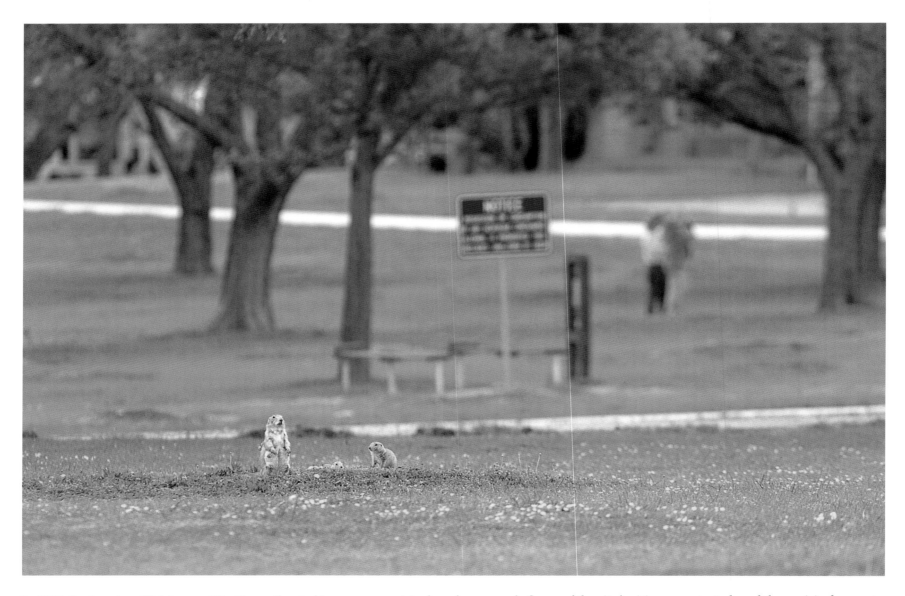

In 1997, the Lawton, Oklahoma, City Council voted to remove prairie dogs from a park. Some of the city's citizens protested, and the prairie dogs got a reprieve.

The Prairie Dog

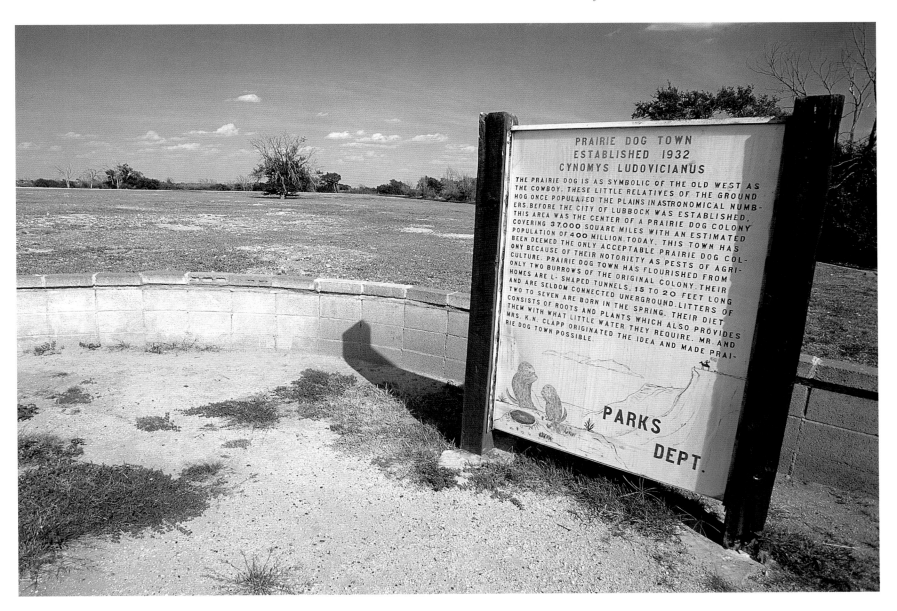

The text on the sign reads:

PRAIRIE DOG TOWN
ESTABLISHED 1932
CYNOMYS LUDOVICIANUS
THE PRAIRIE DOG IS AS SYMBOLIC OF THE OLD WEST AS
THE COWBOY. THESE LITTLE RELATIVES OF THE GROUND
HOG ONCE POPULATED THE PLAINS IN ASTRONOMICAL NUMB-
ERS. BEFORE THE CITY OF LUBBOCK WAS ESTABLISHED,
THIS AREA WAS THE CENTER OF A PRAIRIE DOG COLONY
COVERING 37,000 SQUARE MILES WITH AN ESTIMATED
POPULATION OF 400 MILLION. TODAY, THIS TOWN HAS
BEEN DEEMED THE ONLY ACCEPTABLE PRAIRIE DOG COL-
ONY BECAUSE OF THEIR NOTORIETY AS PESTS OF AGRI-
CULTURE. PRAIRIE DOG TOWN HAS FLOURISHED FROM
ONLY TWO BURROWS OF THE ORIGINAL COLONY. THEIR
HOMES ARE L-SHAPED TUNNELS, 15 TO 20 FEET LONG
AND ARE SELDOM CONNECTED UNERGROUND. LITTERS OF
TWO TO SEVEN ARE BORN IN THE SPRING. THEIR DIET
CONSISTS OF ROOTS AND PLANTS WHICH ALSO PROVIDES
THEM WITH WHAT LITTLE WATER THEY REQUIRE. MR. AND
MRS. K.N. CLAPP ORIGINATED THE IDEA AND MADE PRAI-
RIE DOG TOWN POSSIBLE.

PARKS
DEPT.

MacKenzie Park in Lubbock, Texas, has successfully used a barrier wall to contain prairie dogs.

through the heartland of America, all eyes are glued on Prairie Dog Pete every February 2—Groundhog Day throughout most of the country. Since there are no groundhogs in Texas, residents of the Lubbock area look to the only rodent they can for guidance on the coming of spring.

Although many look at the prairie dog as a cute mascot, still others see it as an animal that is to be taken seriously and protected as part of the plains environment. In Oklahoma, the Lawton City Council voted on August 12, 1997, to remove all of the prairie dogs from Elmer Thomas Park—a large, open-air park on the north edge of downtown where a small lake and hiking trails bisect an immense prairie dog town. The plan was simple: all of the dogs would be flooded from their holes and safely relocated. But the City of Lawton did not count on the overwhelming opposition it received from its citizens. Editorials, petition drives, and e-mail floods multiplied until the council finally forged a compromise: The prairie dogs would be left in the park, but their ranks would be thinned.

In Lafayette, Colorado, and Santa Fe, New Mexico, the situation became much more serious. For example, in Santa Fe, the city council, fearing that the prairie dogs and their burrows in a city park would endanger the many children who played

Oats are often laced with poison to quickly exterminate prairie dogs.

there, adopted a measure early in the spring of 1998 that would use a poisonous compound called Fumitoxin, a gaseous version of aluminum phosphide, to get rid of the prairie dogs. News of the decision drew fire from a local environmentalist group, People for Native Ecosystems, and complaints began to pour into the Santa Fe mayor's office. As a result, the city decided to look for an alternative to killing the prairie dogs. They found another local group, the Great Plains Restoration Council, willing to help with the problem. The council would use a water truck and biodegradable soap to flush the dogs out of their homes so they could be caught and relocated. The biodegradable soap, it was claimed, would irritate the eyes of the prairie dogs and force them up from their holes quicker than pure water would. As some city council members pointedly asked, however, where would the prairie dogs be put?

"Where are you going to put them?" become a rhetorical question in Lafayette, Colorado, a small town just east of Boulder, when a developer began poisoning a prairie dog town of two thousand on land on which construction had been set to begin in the spring of 1998. According to the *Boulder Planet*, emotions at the construction site were heated as players on both sides of the prairie dog issue clashed in a principled debate over the value of prairie dogs. Jim Sheeler, reporter for the *Planet*, wrote, "As emotions boiled over, the chirps and yips of the prairie dogs—animals known for their complicated communication system—slowly were silenced." A fourteen-person local task force, made up of ranchers, members of environmental organizations, a woman who lives near a prairie dog colony, officials from the Colorado Department of Wildlife and the Boulder County Health Department, a biology professor from the University of Colorado, and a rangeland science professor from Colorado State University, had actively sought solutions before the poisoning. Although the group did not come up with a workable decision to save the prairie dogs on the development land, they continued to try to develop a plan for the 460 acres of prairie dog town left in the county. Still, their efforts were proclaimed a failure in policy by most in Lafayette.

Susan Jones, an associate professor of history at Colorado University, commented to the *Boulder Planet* on the complicated issue: "We have competed with prairie dogs in these little land wars for years, and Lafayette is one of them; it's only one of thousands. . . . I think prairie dogs are one of the quintessential Western animals. . . . They're not as mystic as a buffalo, they're not as threatening as the wolf, yet they're part of a Western image. . . . I think it will become a flashpoint for the West's changing demographics." Jones is right. Most experts agree that, as the socioeconomic status of the West changes, many more debates on the prairie dog will erupt. Therefore, it is clear that workable solutions in the best interests of all parties involved in the issue are needed.

Hunters pump thousands of dollars into the economy of some plains communities, helping to control prairie dog numbers.

Many papers and studies have suggested ways to control prairie dogs. Several of those methods—from nonlethal (relocation and barriers) to lethal (poisoning and hunting)—have shown promise, but none has actually been recognized as an effective and practical means of controlling prairie dog population booms and subsequent expansion of the rodents' range.

One such nonlethal means is the use of visual barriers. A study conducted by William Franklin and Monte Garrett in 1989 suggests that a physical barrier can be effective in controlling expansion of prairie dog towns. In the study, the researchers placed burlap "fences" as a visual barrier on one site and pine trees on another. They found that the burlap fences, although not completely effective, did control prairie dog movement in the colony, showing a 61 percent reduction in the use of the area by the dogs. The researchers do concede, however, that the prairie dogs readily chewed the burlap and often crawled under it. In the other test area, young Ponderosa pine trees up to six feet tall were planted in parallel rows approximately 162 feet long across the prairie dog town, with each row spaced 54 feet apart. The results for this site were much the same as those for the ones where burlap was used. In both small and large towns in which Franklin and Garrett tried the barriers, the prairie dogs reduced their expansion. The researchers concluded that visual barriers for prairie dog control are potentially useful alternatives to lethal methods of control

"when the latter are legally, socially, or ethically unacceptable." The visual barrier idea is catching on. Fact sheets developed by the City of Boulder [Colorado] Open Spaces Department outline specific steps for constructing a barrier. MacKenzie Park in Lubbock, Texas, also uses a visual barrier, a low concrete wall, to keep a large prairie dog town in check, with good results.

Other ideas for controlling prairie dog expansion vary, and some seem downright radical. Take, for example, the work done by researchers at Colorado State University. As reported in the October 17, 1997, issue of the *Rocky Mountain News,* researchers are working to determine whether chemocontraception is a practical nonlethal means of controlling the rodents. In the study, scientists planned to chemically sterilize fifty male prairie dogs and determine their behavior within a colony of two hundred. The research was not meant to determine whether the dogs would breed, for the effectiveness of the sterilization was well documented. Instead, researchers wanted to determine whether the sterilized but uncastrated males would still exhibit the territorial behavior essential to prairie dog survival. The study revealed that the procedure did not reduce the males' territoriality, so chemocontraception of this kind appears to hold some promise as another nonlethal means of keeping populations in check.

Although many nonlethal modes have been tried and continue to be tested, many people feel that lethal controls of prairie dog population are the only practical means. One such method, which has been around since the war on prairie dogs began in the early part of the twentieth century, involves baiting specific burrows with oats poisoned with 2 percent zinc phosphide or 5 percent strychnine. Zinc phosphide baits have been shown to be effective in reducing prairie dog populations by 96 percent, compared to the 77 percent reduction strychnine control provides. On the other hand, poisoning as a method of controlling prairie dogs bothers some people, who are concerned with the inhumane nature of the control method and the potential danger of setting out poison that can be picked up inadvertently by animals other than prairie dogs. In addition, they are concerned that the effectiveness of such chemical controls could disrupt the local ecological balance, since the prairie dog is a keystone species that supports the lives of many other animals.

A more targeted way of controlling prairie dogs by lethal means—hunting—may be gaining ground. Prairie dogs have been hunted for many years, but the sport is increasing. Some towns of the High Plains even organize hunts in a yearly festival at which hundreds or even thousands of people gather, providing an economic boost to the communities that sponsor such events. For people who advocate prairie dog control with regulated hunting, however, the biggest winners are the landowners. A quick search on the Internet reveals many outfitters who provide guided prairie dog hunts on private land, and

many of those hunts go for well over a thousand dollars for three days' shooting. It does not take long for the income to add up for landowners who may have felt the pinch of a depressed agricultural economy.

According to Kevin Mote, it is important to look at prairie dogs as a renewable resource. If a landowner properly manages his prairie dog town's population, he can hold it static for a number of years and capitalize year after year on the recreational value of prairie dogs while sustaining the ecosystem associated with the town. The missing factor in this equation is determining how many prairie dogs should be shot. Many agree that research on this subject is needed if prairie dog management is to be embraced by landowners. There is potential for economic gain from prairie dog hunting, however.

A Workable Solution?

When in mid-September of 1998 the USFWS acknowledged that the black-tailed prairie dog was in peril because of a lack of management, yet refused to give it emergency status as a threatened species, the NWF hierarchy was somewhat disappointed. Their president, Mark Van Putten, was guardedly optimistic when he stated, "Denial of the emergency listing is unfortunate because this species needs help and needs it now. But we're very encouraged by the official recognition that the prairie dog is in trouble and needs the kind of recovery help that the Endangered Species Act is designed to provide." With that, the NWF prepared to await the further decision of the USFWS. The USFWS stated, "We fully recognize that the current lack of regulatory mechanisms for managing black-tailed prairie dogs could allow for continued prairie dog losses." In the meantime, the USFWS promised to review the petition and make a recommendation accordingly in due time.

Many states, however, were making proactive decisions to conserve the prairie dog in lieu of the federal government's actions. For example, the chief wildlife agency in the Lone Star State, the Texas Parks and Wildlife Department, was one of the first entities to propose an interstate partnership for the conservation of prairie dogs. Under the agreement, states that would potentially be affected by the endangered species

If landowners learn the ecological role of the prairie dog, it may yet be saved.

listing would band together to develop management plans to preclude the listing of the prairie dog. Similar plans have been initiated, with some success, for the swift fox and the lesser prairie chicken, both of which are candidates for the endangered species list. In the plan, state wildlife departments, federal entities, private landowners, and conservation groups would work cooperatively to find a solution and implement management plans to help save the prairie dog. The interstate agreement stressed landowner incentives, such as tax breaks, as a primary impetus for the conservation movement to begin.

What does the future hold for the black-tailed prairie dog? No one knows for sure. One thing is for certain, however: In the conservation world, the prairie dog is bound to be one of the hottest topics in the war over property rights in the next one hundred years.

Epilogue

When I started writing this book on the prairie dog, I knew that challenges awaited me. First, there is not much general literature on prairie dogs, and what is available is so generic that it is hard to glean useful information from it. Scores of scientific journal articles are available, but they can be difficult for the general audience to understand. Therefore, the initial challenge was to gather enough research and literature and then translate technical scientific data into an easy-to-read volume of information about the prairie dog.

The second and perhaps the most difficult challenge of this work was to find a middle ground. It would be easy to write a book on a topic such as the prairie dog and slant it toward the view that the prairie dog need not be managed or controlled. On the other side of the coin, I could have written a text that makes the dogs out to be "devils of the plains." Either way, I feel I would not have been doing justice to the prairie

dog. Therefore, in my endeavor, I sought the middle ground—and it was not always easy to find.

I hold a bachelor of science degree in production agriculture and was raised on a small-time cattle outfit in northeast Texas along the Red River. Historic accounts tell of prairie dog towns that reached as far east as Paris, Texas, along the northern edge of the vast Blackland prairie. The rolling hills I explored as a boy living twenty-five miles west of there definitely would have been within the realm of the dogs. By that time, though, they had been gone for many years. Consequently, I never had any experiences with them, good or bad.

When I moved to the southeastern Texas Panhandle in the early 1990s, I soon discovered that I was in the land of the prairie dogs. Being a published photographer, I started shooting photos of the dogs in their natural habitat. Soon I was asked to give programs at the local Lions and Rotary Clubs on my latest photographic adventures. Each time I would show the slides, I would try to be neutral on the prairie dog issue, because some of the audience (my friends among them) were ranchers and farmers and held unsympathetic views about the prairie dogs that had been passed down through generations. Simply put, I did not want to step on any toes. After my first program though, a gentleman whom I have known for some time approached me and said, "You know, that's the first time I've ever heard anything positive about prairie dogs." Right then I knew that that sentiment was much more prevalent than anyone cared to realize or admit.

This book, I hope more than anything, will inform with facts—not biases or emotions. We owe it to our children and their children to be good stewards of the land and its inhabitants. The prairie dog is, unfortunately, a pawn in a game of politics, propaganda, emotions, and misinformation. I hope this book will develop and foster an appreciation for wildlife as well as economic gains. There is middle ground on the prairie dog issue. The trick is finding it before it is too late for prairie dogs, private property owners, and conservation groups. It will be a tough job, but not an impossible one.

Humankind is the steward of the land—appointed by divine instruction. In the opening pages, the Bible reads:

And God said, "Let us make man in our image, after our likeness: and let them have dominion over the fish of the sea, and over the fowl of the air, and over the cattle, and over all the earth, and over every creeping thing that creepeth upon the earth."

—Genesis 1:26

These are common-sense words to live by.

Notes

1. Captain Marcy made a mistake in math in his journal. Taking into account that there are 640 acres per square mile, the total number of acres that Marcy was describing was only 400,000.

2. The Llano Estacado refers to the Texas High Plains west of the Caprock Escarpment. It runs roughly from the top of the Texas Panhandle south to about sixty miles south of Lubbock.

3. Succession refers to the force in nature that governs the pattern of development of various plant communities from grass prairies to shrubs and eventually mature trees.

4. "Threatened," as defined in the Endangered Species Act, means that a species is likely to become endangered in the foreseeable future. An endangered species is defined as one that is likely to become extinct in the foreseeable future.

Appendix: Where to See Prairie Dogs

In the United States, many public and private zoos have exhibits that include prairie dogs. In order to see prairie dogs in their native habitat, however, one must make a trip to the Great Plains. Following is a partial listing of places in which prairie dogs can be seen in their natural habitat. Some are listed by the closest city's name, while others are listed by the park name. For a more detailed account, check with a local chamber of commerce as well as state and federal wildlife agencies.

Colorado
> Grand Junction
> Delta
> Montrose

Kansas
> Kanopolis State Park near Marquette
> Prairie Dog State Park near Norton

New Mexico
> Kiowa National Grasslands near Clayton
> Living Desert State Park near Carlsbad

Oklahoma
> Rita Blanca National Grasslands near Boise City
> Wichita Mountains National Wildlife Refuge
> near Lawton
> Guymon Game Reserve near Guymon
> Beaver River Wildlife Management Area near Beaver
> Canton Lake near Canton
> Elmer Thomas Park in Lawton

South Dakota
> Wind Cave National Park near Pringle
> Custer State Park near Rapid City
> Buffalo Gap National Grassland near Hot Springs
> Black Hills National Forest near Rapid City

Texas
> Arrowhead Lake State Park near Wichita Falls
> Rita Blanca National Grasslands near Dalhart
> Buffalo Lake National Wildlife Refuge near Hereford
> Muleshoe National Wildlife Refuge near Muleshoe
> MacKenzie Park in Lubbock

Wyoming
> Devil's Tower National Monument near Hulett
> Thunder Basin National Grasslands near Newcastle

Bibliography

The sources listed in the bibliography represent an assortment of literature I used to bring the text of this book together. For my primary sources I coupled my firsthand observation of prairie dogs, while photographing them, with a variety of written materials. First, scientific journals were extremely helpful in shaping some of the scientific topics that I wanted to address in the text. Other, more general materials were obtained from popular magazines, state wildlife department bulletins, newspaper articles, and one of the most crucial sources of information, the Internet.

The vast amount of resources available on the Internet allowed me to stay current on the issues I discussed in the last section of the book, "The Prairie Dog Wars." Any browser will give you URLs for sites about prairie dogs.

Agnew, William, Daniel Uresk, and Richard Hansen. "Flora and Fauna Associated with Prairie Dog Colonies and Adjacent Ungrazed Mixed-Grass Prairie in Western South Dakota." *Journal of Range Management,* March 1986.

Associated Press. "Castration May Be Tried on Prairie Dogs." *Rocky Mountain News,* October 17, 1997.

———. "Dogged by Dispute: Ranchers, Conservationists Square Off over Prairie Pups." *Dallas Morning News,* August 18, 1998.

Baker, Bruce. *Avian Biodiversity On and Off Prairie Dog Colonies across the Great Plains.* Fort Collins, CO: U.S. Geological Survey, n.d.

Bailey, Vernon. *Biological Survey of Texas.* North American Fauna, No. 25. Washington, D.C.: U.S. Department of Agriculture, Biological Survey, 1905.

Becker, Kevin. "Little Dog on the Prairie." *Kansas Wildlife and Parks,* n.d.

Biggins, Dean. *Comparative Studies of Black-footed Ferrets and Siberian Polecats.* Fort Collins, CO: U.S. Geological Survey, n.d.

———. *Evaluation of Black-footed Ferret Release Techniques.* Fort Collins, CO: U.S. Geological Survey, n.d.

———. *Functions of Prairie Dog Complexes as Habitat for Black-footed Ferrets.* Fort Collins, CO: U.S. Geological Survey, n.d.

———. *Studies of Prairie Dog Populations.* Fort Collins, CO: U.S. Geological Survey, n.d.

Blair, Walter. *Tall Tale America: A Legendary History of Our Humorous Heroes.* New York: Coward-McCann, 1944.

Cheatheam, Lloyd. "Density and Distribution of the Black-tailed Prairie Dog in Texas." *Texas Journal of Science,* September 1977.

Cincotta, Richard, Daniel Uresk, and Richard Hansen. "Plant Compositional Change in a Colony of Black-tailed Prairie Dogs in South Dakota," Paper presented at the Ninth Great Plains Wildlife Damage Control Workshop, Fort Collins, CO, April 1989.

City of Boulder Open Spaces Department. *Prairie Dog Relocation.* Boulder, CO: City of Boulder, 1996.

———. *Prairie Dog Visual Barrier.* Boulder, CO: City of Boulder, 1996.

Collins, Alan, John Workman, and Daniel Uresk. "An Economic Analysis of Black-tailed Prairie Dog (*Cynomys ludovicianus*) Control." *Journal of Range Management,* July 1984.

Coppock, Layne, and James Dettling. "Alteration of Bison and Black-tailed Prairie Dog Grazing Interaction by Prescribed Burning." *Journal of Wildlife Management,* 1986.

Costello, David. *The World of the Prairie Dog.* Philadelphia: J. B. Lippincott Company, 1970.

Cottam, Clarence, and Milton Caroline. "The Black-tailed Prairie Dog in Texas." *Texas Journal of Science,* 1965.

Davis, William, and David Schmidly. *The Mammals of Texas.* Austin: Texas Parks & Wildlife Press, 1994.

Dold, Catherine. "Making Room for Prairie Dogs." *Smithsonian,* March 1998.

Doughty, Robin. *Endangered Species: Disappearing Animals and Plants in the Lone Star State.* Austin: *Texas Monthly* Press, 1989.

England, Nelson. "Little Dogs on the Prairie." *Texas Highways,* May 1997.

Flores, Dan. Personal interview on September 3, 1998 concerning the history of the prairie dog.

Foster, Nancy, and Scott Hygnstrom. *Prairie Dogs and Their Ecosystem.* Lincoln: University of Nebraska-Lincoln, Department of Forestry, Fisheries, and Wildlife, 1990.

Franklin, William, and Monte Garrett. *Nonlethal Control of Prairie Dog Colony Expansion with Visual Barriers.* Bethesda, MD: The Wildlife Society, 1989.

Gilliand, Rick. "The Blacktailed Prairie Dog." *The Texas Safari Quarterly,* date unknown.

Frisina, Michael, and Jina Mariani. "Wildlife and Livestock as Elements of Grassland Ecosystems." *Rangelands,* February 1995.

Glass, Anthony. *Journal of an Indian Trader: Anthony Glass and the Texas Trading Frontier, 1790–1810.* Ed. Dan Flores. College Station: Texas A&M University Press, 1985.

Haley, J. Evetts. *Charles Goodnight, Cowman and Plainsman.* Norman: University of Oklahoma Press, 1936.

Hansen, Richard, and Ilyse Gold. "Blacktail Prairie Dogs, Desert Cottontails and Cattle Trophic Relations on Shortgrass Range." *Journal of Range Management,* May 1977.

Hays, A. B. *Memoirs of the Prairie Dog: 1888 to 1939.* Canyon, Texas: Panhandle-Plains Historical Museum, 1939.

Holmes, Bob. "The Big Importance of Little Towns on the Prairie." *National Wildlife Magazine,* June 1996.

Hoogland, John. *The Black-Tailed Prairie Dog: Social Life of a Burrowing Mammal.* Chicago: University of Chicago Press, 1995.

———. Personal interview on September 30, 1998 concerning the vocal patterns of prairie dogs.

Hyde, Robert. *Prairie Dogs and Their Influence on Rangeland and Livestock.* Fort Collins: Department of Range Science, Colorado State University, n.d.

Hygnstrom, Scott, and Dallas Virchow. *Prairie Dogs: Damage Prevention and Control Methods.* Lincoln: Cooperative Extension Division of the University of Nebraska, 1994.

Kellogg, Steven. *Pecos Bill.* New York: William Morrow and Company, 1986.

Krausman, Paul, ed. *Rangeland Wildlife.* Denver: Society for Range Management, 1996.

Krueger, Kristen. "Feeding Relationships among Bison, Pronghorn, and Prairie Dogs: An Experimental Analysis." *Ecology,* 1986.

Long, Michael. *The Vanishing Prairie Dog.* Washington D.C.: *National Geographic,* April 1998.

Marcy, Randolph, and George McClellan. *Adventure on the Red River.* Ed. Grant Foreman. Norman: University of Oklahoma Press, 1937.

Martin, Suzanne. "Great Plains Digger." *Texas Parks & Wildlife,* January 1992.

McNulty, Faith. *Must They Die?* New York: Doubleday & Company, 1971.

Merriam, C. H. "The Prairie Dog of the Great Plains." In *Yearbook of the U.S. Department of Agriculture, 1901,* pp. 257–70. Washington D.C., Department of Agriculture, 1902.

Miller, Brian. *A History of the Prairie Dog "Problem."* N.p., n.d.

———, Dean Biggins, and Richard Reading. "A Proposal to Conserve Black-Footed Ferrets and the Prairie Dog Ecosystem." New York, *Environmental Management,* 1990.

———, and Gerardo Ceballos. "The Prairie Dog and Biotic Diversity." *Conservation Biology,* September 1994.

"Modern-day Modest Proposal for Prairie-Dog Problem." Editorial. *Santa Fe New Mexican,* April 2, 1998.

Mote, Kevin. Personal interview, July 14, 1998, concerning the conservation of prairie dogs.

National Wildlife Federation. "Government Confirms Black-Tailed Prairie Dog is in Jeopardy: NWF Awaits November Decision on Threatened Listing." National Wildlife Federation news release. Washington D.C., September 14, 1998.

———. "NWF Seeks Prairie Dog Listing—Action will Save Wildlife and Grassland Habitats." National Wildlife Federation news release. Washington D.C., July 31, 1998.

Neary, Ben. "Prairie Dog Gassing Draws Group's Fire." *Santa Fe New Mexican,* March 31, 1998.

Nebraska Game and Parks Commission. *Nebraska Wildlife: Black-tailed Prairie Dog.* Lincoln: Nebraska Game and Parks Commission, n.d.

O'Meilia, M. E., F. L. Knopf, and J. C. Lewis. "Some Consequences of Competition between Prairie Dogs and Beef Cattle," *Journal of Range Management,* September 1982.

Owen, B. A. Interview manuscript for the Panhandle-Plains Museum. Panhandle-Plains Historical Museum, Canyon, Texas, 1930s?

Parker, Gretchen. "Prairie Dog Pete Peeks at Shadow." *Lubbock Avalanche-Journal,* February 2, 1997.

Powell, Kenneth. *Decline and Current Status of the Black-Tailed Prairie Dog.* Manhattan: U.S. Fish and Wildlife Service, n.d.

Reading, Richard. *The Valuational Aspects of Prairie Dog Conservation.* Fort Collins, CO: Society for Conservation Biology, 1995.

Robertson, Pauline, and R. L. Robertson. *Panhandle Pilgrimage: Illustrated Tales Tracing History in the Texas Panhandle.* Amarillo: Paramount Publishing Company, 1989.

Schenbeck, Greg. *Black-Tailed Prairie Dog Management on the Northern Great Plains: New Challenges and Opportunities.* Nebraska: U.S. Forest Service, n.d.

Schmitt, Larry. "Lawton Prairie Dogs." *Lawton Constitution,* August 13, 1997.

Sheeler, Jim. "Digging for Solutions in Prairie Dog Debate." *Boulder Planet,* April 7, 1998.

Skagen, Susan. *Prairie Dogs as Keystone Species in Prairie Ecosystems.* Fort Collins, CO: U.S. Geological Survey, n.d.

Snell, Glen, and Bill Hlavachick. "Control of Prairie Dogs—the Easy Way." *Rangelands,* December 1980.

Texas Parks and Wildlife Department. "TPW Proposes Alternative to Listing of Prairie Dog." Texas Parks and Wildlife Department news release, Austin, August 10, 1998.

U.S. Department of the Interior. *Endangered and Threatened Wildlife and Plants: 12-Month Find.*" Pierre, SD: U.S. Fish and Wildlife Service, 1995.

Uresk, Daniel. "Effects of Controlling Black-tailed Prairie Dogs on Plant Production." *Journal of Range Management,* September 1985.

———, and Deborah Paulson. *Estimated Carrying Capacity for Cattle Competing with Prairie Dogs and Forage Utilization in Western South Dakota,* paper presented at the Management of Amphibians, Reptiles, and Small Mammals in North America symposium in Flagstaff, Arizona, July 19–21, 1988.

———, James MacCracken, and Ardell Bjugstad. *Prairie Dog Density and Cattle Grazing Relationships.* Rapid City, SD: U.S. Department of Agriculture, n.d.

Van Der Werf, Martin. "Researcher Deciphering Prairie Dog Sounds." *Dallas Morning News,* September 14; 1998.

Vosburgh, Timothy. "Impacts of Recreational Shooting on Prairie Dog Colonies." Thesis, Montana State University, Bozeman, April 1996.

Weniger, Del. *The Explorers' Texas,* vol 2, *The Animals They Found.* Austin: Eakin Press, 1997.

Index